To Mary Jo

May 2?, 20??

African Americans
OF
ALEXANDRIA
VIRGINIA
BEACONS OF LIGHT IN THE TWENTIETH CENTURY

M000274811

Thanks for your interest and enjoy the stories —
Christa Watters

Thanks for your involvement!
James E. Henson Sr.

Thank you for your support — Best wishes,
[signature]

Char McCargo Bah, Christa Watters,
Audrey P. Davis, Gwendolyn Brown-Henderson
and James E. Henson Sr.

Mary Jane,
Thanks!
Char Bah

Thank You For your support
Gwen Brown-Henderson

Charleston — THE History PRESS — London

Published by The History Press
Charleston, SC 29403
www.historypress.net

Front cover, left to right:
Charles Fremont West throwing a javelin as a college athlete. *Photo courtesy of Linda West Nickens/ The Learned T. Bulman '48 Archives & Museum, Washington & Jefferson College, Washington, Pennsylvania.*
Ferris Holland, science teacher, coach and mentor, performing a science experiment for his students. *Alexandria Public School Archives/Records, Alexandria, Virginia.*
Raymond Leroy Williams, a former Parker-Gray High School leader and football player. *Alexandria Public School Archives/Records, Alexandria, Virginia.*
Cast of the 1927 Parker-Gray school play *Aaron Slick from Punkin Crick. Alexandria Black History Museum, Alexandria, Virginia.*

Back cover, left: Arrest of the "sit-down strikers" at the Alexandria Free Library, August 21, 1939. *Alexandria Black History Museum, Alexandria, Virginia.*
Back cover, right: Four generations of women—Helen Day (far right) with her mother, Lucy Washington, holding great-granddaughter Carol Lee, with Helen's daughter, Bernice Lee (far left). *Alexandria Black History Museum, Alexandria, Virginia.*

First published 2013

Manufactured in the United States

ISBN 978.1.62619.013.9

Library of Congress CIP data applied for.

This book is dedicated to all the Alexandria African Americans of the twentieth century who had the vision and the daring to dream big and act boldly on what they could do rather than what they could not do.

CONTENTS

Contents

CONTENTS

FOREWORD

When the committee working on the narratives of the people featured in this book first came to me to say they had received a contract to publish the stories as a book, I was pleased—not only because the book recognizes deserving people but also because I had known some of those people. I am not just the mayor here. I was born and raised in Alexandria, Virginia, and I am proud to be the first African American mayor in our city's history. I look back at my achievements and those of the members of my generation of African Americans and the generations coming up behind me, and I recognize that we are all standing on the shoulders of these men and women who truly were beacons of light and agents of change in Alexandria in the twentieth century.

I was raised in public housing and attended local schools. I graduated from T.C. Williams High School in 1968. You may remember some of the story of "T.C.," as it is known locally, and the turbulent times of its integration from the film *Remember the Titans*. It was not an easy time, but it was a time of change and growth for our city as for much of our country. After high school, I received an academic scholarship to Quinnipiac College in Connecticut, where I majored in accounting and business administration. When I came back to Alexandria after graduation in 1972, I found employment in a construction company, where I learned all aspects of the business and eventually rose to become vice-president. In 1987, I founded my own construction business, Wm. D. Euille & Associates, Inc., leading the firm as president and chief executive officer and now chairman of the

Mayor William D. Euille of
Alexandria, Virginia. *Courtesy of
Mayor's Office, Alexandria, Virginia.*

board of directors. I became active in civic life and served on the Alexandria
School Board and on countless community boards and committees. In 1994,
I was elected to city council, and in 2003 was elected mayor.

Some of the "Beacons of Light" whose narratives you are about to read
were alive in my lifetime (and, in fact, some are still among us today), while
others preceded me and passed on before I could know them. But all of
them made a positive impact on the city and helped bring about the many
changes that have made the Alexandria of today such a richly vibrant and
culturally diverse city. Some of them fought for integration. Some risked
their jobs to do so. Others had the courage to start their own businesses,
excel at a profession or a craft or innovate in the way an organization was
run. In some way, each of them merits our attention, our respect and honor.
They were born in a time of segregation in a city that still lived with many of
the divisions left behind by the Civil War. They lived alongside the dominant
white society of their time, building a community of their own while helping

to build the city that we all jointly lived in despite the fact that so much of our lives were lived separately.

The African American community of Alexandria had a rich and varied social life lived parallel to the other community, but their stories were rarely brought to public recognition. This book remedies the years of oversight of their achievements. Some of these Beacons of Light achieved great things, becoming leaders in the fields of religion, medicine, business, education, the military, the arts, sports, science or civic life. Others lived more modestly, hardly moving into the limelight in the wider world. But they all made a difference. They set examples and acted as mentors and role models by living selflessly and courageously, taking risks to move society ahead. Or they simply set personal records of achievement and excellence. This book honors those individuals whose action and achievements exemplify the ideals of integrity, goodness, honor and hard work.

I am so pleased that our city has moved to fill a void in the history of African Americans in Alexandria. This book will add to the growing documentation of life in the community of African Americans that was forged in Alexandria out of a mix of slaves, free blacks and contrabands that burgeoned during and after the Civil War. I believe the recognition of these individuals is long overdue and that as it brings attention and honor to lives too long kept out of our city's public histories, it helps bring balance to the record of who and what we are. These narratives show that Alexandria's history is richer and deeper and wider than we learned in the history books back when I attended school. And though the records may be sparse in some cases, they shed new light on people who made a difference. I am pleased and proud to commend this book to you.

—William D. Euille, Mayor, Alexandria, Virginia
January 2013

PREFACE

This book collects the narratives of sixty-three African Americans who had an impact on the Alexandria community in the twentieth century, with a particular focus on the period of 1920 to 1965. Originally, short narratives were compiled by members of the Charles Houston Ad-Hoc Naming/Narrative Committee, appointed by the city to recognize the achievements of people in such categories as law, medicine, religion, business, sports, science, the military, community service and the arts. Those selected will be recognized in rooms of the Charles Houston Recreation Center, located in Alexandria's historically black Parker-Gray neighborhood. When the committee finished the original project, we recognized that in the process of gathering the short narratives, we had in some cases acquired more information that deserved a wider audience. So a small group of us decided to continue the project and turn it into a book.

We are calling the individuals recognized here "Beacons of Light" because they did exemplary things in difficult times. They served as change agents who made possible a better life for their children and others who came after them. For some, the goal was simply to support their families and be good citizens in their churches, schools and communities. Others had a vision of a wider goal: equal rights—full access to the community in which they lived and worked; to education, medical care and jobs for which they were qualified; and also the right to vote and to participate in all aspects of civic life. Most of them not only lived through the transition from segregation to integration but also helped achieve that transformation and all the reforms

it encompassed. Change did not come easily, and it took too long—but it did come, and they were part of it.

The book provides a mosaic of a community of individuals who strove to be better, to educate and motivate their children and to gain equality of opportunity in the workplace. Some rose to prominence in the wider world, like Rutherford Hamlet Adkins, a Tuskegee Airman who was also the first African American to earn a doctorate from The Catholic University of America. Some seemed to be just ordinary folks, but when life tested them, they revealed extraordinary moral strength and character. Blois Oliver Doles Hundley was a school cook who joined other parents in a 1958 federal lawsuit demanding that their children be admitted to previously all-white schools. They won, but the school system fired Mrs. Hundley for being a plaintiff in the suit.

The individuals included here were people worth emulating. They did not shy away from community involvement even though many worked at more than one job. Ministers were also schoolteachers, a photographer was also a salesman, a musician was also a professor and an early lawyer earned his living as an elevator operator. These were hard lives, lived in hard times. We salute them and honor them.

The editorial team: Char McCargo Bah, Gwendolyn Brown-Henderson, Audrey P. Davis, James E. Henson Sr. and Christa Watters

Alexandria, Virginia
May 1, 2013

ACKNOWLEDGEMENTS

This book was a collaborative project. Many people and institutions assisted us along the way in developing these biographical narratives. We particularly wish to acknowledge the support of the City of Alexandria, including Mayor William D. Euille, City Manager Rashad Young, Deputy City Manager Michele Evans, City Attorney James L. Banks and Director J. Lance Mallamo of the Office of Historic Alexandria and his assistant, Madeline Shaw. Former Alexandria Public Information Officer Amy Bertsch and current Communications Officer Andrea Blackford helped us at the beginning of the project. Dennis Doster, Jewel Plummer, Shoshanna Roth and Catherine Weinraub of the Alexandria Black History Museum supported our meetings and searches in the archives of the Alexandria Black History Museum.

We thank the members of the original Charles Houston Ad-Hoc Naming/ Narrative Committee, who selected the people whose stories they believed deserved to be told, and we particularly thank those members of that group who researched, compiled or wrote narratives of those nominees. They are credited in the contributor's section.

Others who helped make this book possible by providing or verifying information include George and Doris Washington, Ferdinand T. Day, Gwen Day Fuller, Mumini M. Bah, Constance H. Bradley, Ronald E. Burke Sr., Dr. Nancy Durant-Edmonds, Charlene Taylor Napper, Norma J. Turner, Corrine Jackson Lee Dixon, Janice Lee Wardlaw Howard, Deborah Ford Nelson, Rita Murphy Harris, Arlett Slaughter-Reddick,

Sharon Young, Diane Charity Marshall, Lawrence P. Robinson, Shirley Anntranette Harris, Dr. Arthur C. Dawkins, Rosette Graham of Alfred Street Baptist Church, Marie E. Castillo, Judy Williams of Shiloh Baptist Church in the District of Columbia, Isabel Crocker, Ann Baltimore Flye, Wilhelmina Ellis, Theodosia Smith, Carolyn Phillips McCrae, Leo A. Brooks Sr., Gloria Tancil Holmes, Thomas H. Turner and Christyne M. Douglas, MLIS, archivist at Meharry Medical College Library. Amy Welch of the U. Grant Miller University Library at Washington and Jefferson College in Pennsylvania was also very helpful.

In the Alexandria Library system, we had help from Branch Manager George Combs, Reference Librarian Leslie Anderson and Media Librarian Julia Downie—all of the Local History/Special Collections section. Valerie Meyer of the Alexandria City Public Schools Records Center helped with photographs.

Reverend Dr. Daniel L. Brown of First Agape Community of Faith, Lucretia Martin and Vivian Stewart, Michael Charity, Laverne Wanzer, Liz Dickson, Becky Mays Jenkins, Patricia Jordan Campbell and Gary Jordan provided useful information about some of our subjects.

Photographer Nina Tisara, director of Living Legends of Alexandria, provided us with several excellent photos originally taken for the Living Legends project. Other photos came from family members and church offices that gave of their time to help us find particular photos, often from long ago.

We all thank family members and friends for supporting us during the project, for being there to read and offer suggestions. We recognize there will be omissions, failings and shortcomings in our project, but we have strived to do our best to begin closing the gap and correcting the lack of adequate histories of the African American community of Alexandria. We hope our readers will communicate back to us, giving us new data, more details and richer context for future efforts. (Contact us at changeagents818@yahoo.com)

CONTRIBUTORS

Char **McCargo Bah** is a professional genealogist. She has been featured in several television and radio interviews on genealogical topics and has appeared on the *History Detectives* program on PBS. She participated in a documentary for Ellis Island in New York on her family's genealogy. Char has written many articles for genealogical publications as well as her blog (www.theotheralexandria.com) and has published a short story in an anthology. A 1975 graduate of T.C. Williams High School in Alexandria, Virginia, she holds undergraduate degrees in urban studies and in African American history from the University of the District of Columbia and certificates in paralegal and legal investigation from John Tyler Community College. She is working on an advanced study program in genealogy methodology from the University of Toronto. She received the 2011 Volunteer Award from the Virginia Genealogical Society and the 2009 Alexandria Special History Award from the Alexandria Historical Society. Char is a coauthor and the managing editor of this project. She contributed twelve biographical narratives and three chapter introductions to this book.

Phillip Bell owns a funeral home with his daughter, Winona Morrissett Johnson. He graduated in 1949 from Parker-Gray High School. After high school, he went into the military. Mr. Bell attended mortician school in New York and has more than sixty years of experience in the funeral home business. He is a member of Roberts Memorial United Methodist Church. Mr. Bell contributed a biographical narrative on Ferris Holland.

CONTRIBUTORS

Amy Bertsch has been an employee of the City of Alexandria since 1996, including five years with the Office of Historic Alexandria, where she promoted Alexandria's museums and history and conducted historical research. She is a graduate of West Virginia University and completed a historic preservation certificate at Northern Virginia Community College in 2012. Among her publications is *Alexandria Police Department* (Arcadia, 2006), a photo history of Alexandria's police force that she researched and compiled. Other projects include a digital exhibit of Northern Virginia schools designed by architect Charles M. Robinson, a study of stoneware potters from Loudoun County and an interpretation of a Civil War–era photograph of enslaved people near Alexandria. Amy contributed two biographical narratives to this book.

William Bracey is a retired lawyer who was born in Alexandria, Virginia. He attended Charles Houston Elementary School and graduated in 1961 from Parker-Gray High School. He is a 1973 graduate of Howard University Law School. Mr. Bracey is a member of Russell Temple C.M.E. Church and is an officer in his homeowner's association. He collaborated on the biographical narrative of Harry S. Burke.

Deborah Thomas-Campbell has worked in the community as a pastor, counselor and family therapist. She is a licensed clinician and serves as clinical director for an area nonprofit organization. Earlier in her life, she studied opera at the Sherwood Conservatory in Chicago, Illinois. She traveled the United States with a Russian opera company prior to studying at the Wesley Theological Seminary. She contributed to the biographical narrative of her grandfather, Samuel A. Tucker.

Audrey P. Davis is the acting director of the Alexandria Black History Museum, where she has been employed since 1993. Audrey has served as president of both the Alexandria Historical Society and the Virginia Association of Museums and is on the boards of numerous organizations, including the National Preservation Institute, Living Legends of Alexandria, Frederick Douglass Historic Home and Site, the Northern Virginia Association for History and Gunston Hall Plantation. She has done video productions with the National Trust for Historic Preservation and local and national media outlets, including public television and C-SPAN. She holds both BA and MA degrees in art history from the University of Virginia. She is also a graduate of the Museum of Early Southern Decorative Arts Summer Institute and the Smithsonian Institution's Awards for Museum Leadership Institute. As one of the coauthors of this book, she contributed to five biographical narratives, wrote two chapter introductions and helped proofread all content.

Eudora Lyles-Forrest is the third child of Eudora N. Lee Lyles, one of the subjects of this book. Born and raised in Alexandria, Eudora attended Charles Houston Elementary School and Parker-Gray High School. She majored in vocal music education at Virginia State University. She is a member of Meade Memorial Episcopal Church in Alexandria, where she serves on the vestry and the search committee. She also belongs to the Episcopal Church Women and is the director of music and worship and the Gospel Truth Choir. She collaborated on the biographical narrative of her mother, Eudora N. Lee Lyles.

Gwen Brown-Henderson is a retired federal government employee with forty-one years of service. Gwen was born in Alexandria, where she attended Lyles-Crouch Elementary School, Parker-Gray Middle School and T.C. Williams High School, graduating in 1968. She attended Northern Virginia Community College. Gwen is one of the founding board members of the Alexandria Old School Alumni Association, Inc. and currently serves as the organization's president. She is a member of Ebenezer Baptist Church in Alexandria. With deep roots in and wide knowledge of Alexandria, coauthor Gwen Brown-Henderson contributed to six biographical narratives and helped proofread all content of this book.

James E. Henson Sr., Esq. is a retired attorney. He was the first African American lawyer to serve as assistant county solicitor of Howard County in Maryland. He also served as human rights administrator for Howard County and as deputy director for the Maryland Commission on Human Relations. He has taught business law at Morgan State University and Howard Community College in Maryland. Prior to his law career, Mr. Henson served twenty years in the United States Air Force, retiring as a master sergeant. He was born in Alexandria, Virginia, and graduated in 1954 from Parker-Gray High School. He is a former president of Alexandria's Departmental Progressive Club and one of the founders and a former president of the Alumni Association of Parker-Gray School. Mr. Henson is the great-nephew of Matthew A. Henson, co-discoverer of the North Pole, and the relative of the famous Josiah Henson, who was the basis of the character "Tom" in the novel *Uncle Tom's Cabin*. He is chairman of the Charles Houston Ad Hoc Naming/Narrative Committee and the Change Agents for Historic Alexandria book project. A coauthor of this book, he contributed to fourteen biographical and introductory narratives.

Becky Mays Jenkins is coordinator for the Department of Patient and Family Centered Care at the Department of Defense. She attended Alexandria, Virginia public schools. The daughter of Elsie Charity Taylor

Jordan, she collaborated on the biographical narrative of her mother. Ms. Jenkins is a minister, a world traveler and an acclaimed gospel vocalist. She is a member of Ebenezer Baptist Church in Alexandria, where she chairs several groups.

Thomas Harold and Bernice Robinson Lee are a husband-and-wife team who helped us greatly in providing historical information for this book. Both graduated from Parker-Gray High School in Alexandria, Virginia, in 1944. Mr. Lee graduated from Howard University as a civil engineer, and Mrs. Lee graduated from Fisk University with a biology degree. Both of them spent their working careers in Chicago, Illinois. Mr. Lee retired from the City of Chicago, where he was an assistant city engineer. Mrs. Lee retired after a career as a primary school teacher for the City of Chicago. They are members of Roberts Memorial United Methodist Church. They contributed and collaborated on seven biographical narratives, including those of Mrs. Lee's parents, Lawrence Dunbar Day and Helen Lumpkins Day.

Seth W. Lucas is a retired accountant for the District of Columbia. He was educated in the Alexandria, Virginia public school system and graduated from Parker-Gray High School in 1959. Mr. Lucas is a graduate of Virginia State College. He is a member of Roberts Memorial United Methodist Church. On several occasions, Mr. Robert Strange Sr. told Lucas stories of lawyer Samuel W. Tucker, enabling Mr. Lucas to collaborate on the biographical narrative of Samuel W. Tucker.

Johnathan L. Lyles Sr. is a retired federal government employee. After graduating from Parker-Gray High School in 1958, Mr. Lyles attended Saint Augustine College in Raleigh, North Carolina. He served two years in the United States Army. For thirty-five years, he was a Little League coach in Arlington, Alexandria, Fairfax and Stafford, Virginia. He also taught swimming in the D.C. metropolitan area and at the YMCA in Arlington. His greatest passion was renewing his childhood hobby of painting, and he has become a professional artist. He contributed a biographical narrative of his mother, Eudora N. Lee Lyles.

Harold S. Miner is a physical security specialist assigned to the Eleventh Wing of the United States Air Force and a funeral service intern. He spent seven years with the National Protective Services and nine years of service with the Alexandria Police Department, where he was an affirmative action advocate. A member of Shiloh Baptist Church, he has also been active in the Virginia Morticians Association, Northern Virginia District and the Departmental Progressive Club of Alexandria. Mr. Miner provided useful information for the biographical narrative of his grandfather, John A. Stanton.

Charles H. Nelson is a retired federal government employee. He graduated from Parker-Gray High School in 1949 and served in the United States Air Force prior to entering civilian employment with the government. Mr. Nelson is a member of Shiloh Baptist Church in Alexandria, where he co-chairs the Midday Bible Study, chairs the Senior Ministry and serves as an usher. Mr. Nelson contributed a biographical narrative of his sister, Katie Nelson-Skinner.

Lillian Stanton Patterson is a retired employee of the City of Alexandria, where she was the curator of the Alexandria Black History Museum. She is a 1944 graduate of Parker-Gray High School in Alexandria and received her BA in social studies in 1950 from Storer College in Harpers Ferry, West Virginia. She performed graduate studies in sociology at American University and in early childhood development at the University of Virginia. Ms. Patterson is very active in the Alexandria community. She is the historian for Shiloh Baptist Church and the recipient of numerous community service awards in her city. In 2012, she was named a Living Legend of Alexandria. Ms. Patterson contributed five biographical narratives to this book. Her late husband, Edward Lloyd Patterson, is profiled in this book.

Linwood M. Smith is a retired City of Alexandria employee. He attended Saint Joseph Catholic School, Parker-Gray High School and Virginia State College. He serves his church, Saint Joseph Catholic Church of Alexandria, as an usher. He is also an active volunteer with the Alexandria Black History Museum. Mr. Smith's hobby is woodwork, a skill he learned under the tutelage of Mr. Arnold J. Thurmond—hence he was able to provide much information toward Mr. Thurmond's biographical narrative.

Jacy Thurmond is an executive attorney for the Social Security Administration. One of the sons of Arnold J. Thurmond, Jacy was a collaborator in writing the narrative about his father.

Harriett LaVerne "Vernie" Wanzer was the eldest child of Elsie Charity Taylor Jordan, one of the subjects of this book. Ms. Wanzer was educated in the Alexandria public school system and was employed by the City of Alexandria in the Department of Treasury at the time of her death on June 10, 2012. She was a lifelong member of Ebenezer Baptist Church. Prior to her death, Vernie contributed the initial information for the narrative about her mother.

Christa Watters is a writer and editor with a background in community journalism. She owns and operates WattersEdge, an Alexandria business that provides writing and technical editing services. She has edited several books and served as editor of *Potomac Review*, a regional literary magazine, from

2002 to 2006. She was editor-in-chief of the *Alexandria Gazette Packet* from 1994 to 1996, having worked first as a reporter and then editor for the *Mount Vernon Gazette* and other Connection Newspapers publications beginning in 1989. She serves on the Alexandria Waterfront Commission and on the board of her civic association. Ms. Watters has a BA in government from the University of Massachusetts at Amherst. As a coauthor, she contributed several biographical narratives and chapter introductions and is the book's line editor.

Mark Young is an audio engineer in Orlando, Florida, with the Walt Disney World entertainment team. The grandson of Dr. Herbert G. Chissell and Connie B. Chissell, Mark was born in New York City to Connie Chissell Young, the daughter of Dr. and Mrs. Chissell. Mark earned a music degree in 1980 from Towson State University in Maryland. He continues to get his greatest pleasure in playing the bass guitar and has recently developed an interest in genealogy, which he shares with his two children as they learn the stories of his grandparents' accomplishments. Mark was a collaborator on Dr. and Mrs. Chissell's biographical narratives.

Chapter 1

THE ARTS

Today, the city of Alexandria has a vibrant arts and theater community. The Office of Historic Alexandria has museums representing every aspect of the city's history. MetroStage and the Little Theatre of Alexandria are just two of many theaters presenting plays and musicals. The Torpedo Factory Arts Center, The Athenaeum and Convergence offer the best of Alexandria art. The city's arts community embraces people of all ages and races and blends newer trends with old traditions to appeal to a wide range of audiences and users.

When looking back at the many years of slavery, Jim Crow laws and segregation in America, when daily life was suffused with the struggle for safety, acceptance and dignity, one often wonders, "Was there time for creativity and artistic invention?" The people written about in this chapter answer the question with a resounding "Yes!"

Despite the limitations of a segregated society, these creative agents of progress in the arts thrived and inspired Alexandria's African American citizens with their accomplishments. They came from a community with strong roots in the founding of America, and their ways had been paved by thousands of enslaved men, women and children who had gone before them. But they also carried with them long traditions of creativity in art, both visually and in performance, from the distant geographies and cultures of their origins.

Countless enslaved and free African American men toiled anonymously to build the beautiful houses that line Alexandria's streets. The craft, artistry

and skill of the brick, wood and plaster work are highly prized today. Over the years, hundreds of African American women created beautiful clothes they would never wear, cooked gourmet meals they were not allowed to eat and sang beautiful lullabies to children not their own. They did these routine tasks well, not out of choice but to survive and support their families. The work reflected pride in their skills and a desire to have more in their lives. In private time, and after slavery, these talents came to the forefront, and each generation hoped the next could achieve more.

The growth of a contraband* community in Alexandria saw the first glimmers of hope for a new way of life for African Americans. After the Civil War, African Americans began finding their way in a society that resisted changes in the status quo. The years that followed were fraught with trials testing the spirit of the newly free, but they persevered.

In twentieth-century Alexandria, African Americans established new communities in order to create livable space for themselves despite the restrictions segregation imposed. When going to a movie, shopping or participating in other activities were often frustrating and humiliating experiences, separate but unequal societies developed. This "community" protected and sustained Alexandria's African American residents. While segregation laws existed, African Americans made sure their world included time for spiritual and artistic growth.

Courtney F. Brooks, Dr. Arthur C. Dawkins, Jacqueline Henry Green, Elrich William Murphy and E.L. Patterson lived and worked in a segregated Alexandria. Each fought the confines of this system to build lives and careers that had major impacts during their own lifetimes and for future generations.

Courtney F. Brooks played drums with some of the biggest names in African American music but always found time to help those less fortunate in Alexandria.

Dr. Arthur C. Dawkins brought the art of American Jazz to students at Howard University and in the Alexandria City Public Schools. He also shared his talent through his work with Washington's Arena Stage, the National Symphony Orchestra and the Smithsonian Jazz Masterworks Orchestra. Still active today, he has made a lasting impression on the musical landscape of his hometown and the wider metropolitan area of Washington, D.C.

Jacqueline Henry Green worked as a musician in both the spiritual and secular worlds. Her work as a church choirmaster brought comfort to all who heard her music. Green's work as a teacher ensured a strong musical curriculum was offered to area students.

Photographer Elrich William Murphy captured the life of Alexandria's African American community from the 1930s to the 1970s. His images survive today as historical documents for African American Alexandria.

E.L. Patterson's work as an educator and musician influenced generations of high school students in Alexandria.

These five individuals set a high standard of achievement for the arts in Alexandria. Their work enriched not only the black community but also Alexandria as a whole, making a lasting impact on entertainment, education and history.

*Contrabands were enslaved African Americans who, fleeing other areas in the South, sought protection from the Union forces that had occupied the city of Alexandria. During the Civil War, contraband communities could be found throughout the United States. The most famous community was in Hampton, Virginia, at Fort Monroe.

COURTNEY FRANKLIN BROOKS

November 17, 1923–March 9, 2005

Courtney Brooks combined a career in the federal government with a remarkable career in music while also serving his community through generous volunteer service.

Brooks was born in Alexandria on November 17, 1923, and lived in his native city his entire life except during his service in the United States Army. He attended the Parker-Gray School in Alexandria and then Shaw Junior High and Armstrong High Schools in Washington, D.C. It was during those years that his interest in music blossomed. Shaw was a school that emphasized performance, and at Armstrong, Brooks played drums in the school band. He graduated from Armstrong in 1941 and then went into the army, serving in France and England.

After receiving an honorable discharge from the military, he returned to his hometown and to his love of music. In the 1940s, he formed the Courtney Brooks Band, in which he played the drums. The band played backup or helped open for such groups as The Clovers, Ruth Brown, Etta James, Tina Turner, The Five Keys, The Three Peaches, The Orioles and The Moonglows.

Courtney Franklin Brooks (first row, far right), musician and community leader, receiving an award with other recipients from the Departmental Progressive Club. *Alexandria Library, Special Collections, Alexandria, Virginia.*

He played throughout the South and recorded with two groups, The Buddy Griffin Orchestra and The Chuck Willis Band. Brooks also had a full-time job with the General Services Administration of the Federal Government, from which he retired after thirty years of service.

Following retirement, Brooks was very actively involved in the community and civic life of Alexandria. He worked with the Durant and Cora Kelly Recreation Centers. He organized the first African American professional football team in the area, the Alexandria Rams. He also wrote sports columns for a local newspaper, the *Virginia Arrow*. As a member of the Departmental Progressive Club, he twice served as its president. Mr. Brooks coordinated activities, trips and food distribution for senior citizens. He volunteered with the Muscular Dystrophy Association, Meals on Wheels, the Haunted House for Halloween and Anchor of Hope Ministries, a group that distributed food, clothing and other necessities for the needy.

Brooks was recognized for his service to the community with many awards. Among the honors that he received from the Departmental Progressive Club were its 1995 Community Service Award, a 1997 award recognizing over thirty-five years of membership and, in 1992, an award for Outstanding

Services to the 65th Anniversary Committee. In 2000, his services to the city of Alexandria were recognized by an official proclamation.

Mr. Brooks died March 9, 2005. He is survived by his wife, Lois; his son, Ronald; a sister, Dolores Jackson; two grandchildren, LaJuanna Russell and Marcus Brooks; and five great-grandchildren.

ARTHUR C. DAWKINS, PHD

October 15, 1935—

Arthur C. Dawkins was a Parker-Gray High School graduate who went on to a remarkable career as a musician and educator. He was born in Lexington, North Carolina, on October 15, 1935, and moved with his family to Alexandria in 1940. He attended Alexandria public schools, where he became a serious music student at the age of twelve. His band instructor was E.L. Patterson, who encouraged him to attend Virginia State College (now Virginia State University) upon graduating from Parker-Gray. At Virginia State, Dawkins earned a bachelor's degree in music education. He returned to Alexandria to teach instrumental music at Parker-Gray High School and later became assistant principal at T.C. Williams High School. While teaching and serving as an administrator, he earned his PhD in educational psychology from The Catholic University of America in Washington, D.C.

Dr. Dawkins played in the famous Howard Theater house band and was a part of the inner circle of Washington modern jazz stylists, playing in local clubs and concert venues. He left the Alexandria school system and joined the faculty of Federal City College (now University of the District of Columbia). As a proficient woodwind doubler and flutist, he worked as a freelance musician with various ensembles, including the National Symphony Orchestra and the Smithsonian Jazz Masterworks Orchestra. He was among the first African Americans to perform in the pit orchestras of the major Washington theaters. For more than twenty-five years, he served as the musical contractor for Arena Stage and other concert venues and recording events.

In 1975, Dr. Dawkins was appointed professor of music and director of jazz studies at Howard University, where he served for more than thirty years. In that position, he was a mentor to both students and faculty, often

providing a link between the academic world and the practicing professionals of the art of jazz. He published several articles and book chapters. Among his awards are the Outstanding Faculty Award in the Howard University College of Fine Arts, a Virginia State University Certificate of Merit, the 2005 Benny Golson Jazz Master Award and being named a 2009 honoree of the Alexandria Black History Celebration. He was active in both the International Association for Jazz Education, where he was elected vice-president in 2003, and the Music Educators National Conference.

Dr. Dawkins and his wife, Mary (deceased), had two daughters. A tribute written by W.A. Brower at the time of Dawkins's retirement from Howard University in 2005 credited him with working his way to the top of his profession from modest beginnings, as well as for touching the lives of individuals along the way, "one student at a time, and without ever drawing attention to himself."

Jacqueline LaMarr Henry Green

January 27, 1924–March 5, 2004

Jacqueline Henry Green was a Parker-Gray High School graduate who enriched the musical life of her community in many ways, including serving as director of the senior choir at Alfred Street Baptist Church for forty-seven years. Through her career as a teacher and choir director, she helped many young people learn to appreciate music.

Born in 1924 in Danville, Virginia, to Cora Sue and William T. Henry, Jackie came to Alexandria at the age of four with her parents. After high school, she graduated from Howard University in Washington, D.C. During the summer, she worked in the office of the Adjutant General of the United States Army, where she organized and directed her first choir. Following college, she joined the faculty at Parker-Gray High School as choral music teacher. She wrote the music curriculum for grades K–12 for the Alexandria City Public Schools. She also taught at the Northeast Conservatory of Music. Over the years, she continued her studies at the Peabody Conservatory of Music, the University of Virginia, Virginia State University and The George Washington University. She studied with Robert Harry Wilson at New York University and Elaine Brown at Temple University.

Left to right: Ferdinand T. Day, wife Lucille Day and Jacqueline LaMarr Henry Green (seated), musician, music teacher and choir director. *Photo courtesy of Ferdinand T. Day and Gwen Day Fuller, Alexandria, Virginia.*

Ms. Green organized and directed many choral groups, including those at Alfred Street Baptist Church, Ebenezer Baptist Church, Lomax AME Zion Church, Jacqueline Henry Green Singers, the African Heritage Singers, the Choral Society of Alfred Street and the Choral Arts Society of Alexandria. For a time, she played the organ for Alfred Street's male chorus, The Singing Deacons, organized by her husband, Claude L. Green. She also taught voice, piano and music theory in her private studio.

She was actively involved in the community, serving on the boards of directors of the Performing Arts Association of Alexandria and the Alexandria Symphony Orchestra and as the chair of the Alexandria Commission for the Arts and of the Young Artists Concert Series. She was also active on the Mayor's Performing Arts and Civic Center Task Force. Jacqueline Green received many awards and honors, among them the ALEX Award from the Alexandria Chamber of Commerce, the 1990 Cultural Affairs Award and the Arts Award from the Alexandria Commission on the Status of Women and recognitions from the Hopkins House Association and the Parker-Gray School Alumni Association.

Jacqueline Henry Green died March 5, 2004. She was predeceased by her husband, Claude L. Green.

ELRICH WILLIAM MURPHY

January 31, 1909–March 31, 1993

Elrich William Murphy was a photographer in great demand by the African American community in Alexandria, Virginia. He began taking photographs with his box camera as a hobby in the 1930s, and soon his passion became his profession.

Murphy documented the life of Alexandria's African American community from the 1930s to the 1970s. He photographed church members, social clubs, weddings, local businesses, city workers, civic organizations and the everyday life of his subjects. He cataloged each one of his photos by date and name. Typically, his mode of transportation was by bicycle, on foot or by taking public transportation. Some of his assignments also took him into the District of Columbia, across the river. Before the days of color photography, Murphy developed a method of coloring his photos by hand. The number

of prints in his collection is in the thousands.

Elrich Murphy was born on January 31, 1909, in Alexandria, the son of John Travis Murphy and Rose Evans. He grew up at 923 North Alfred Street. His grandparents, John and Mahala, had lived in Alexandria since the Civil War and were living in the 900 block of North Alfred Street as early as the late 1860s. Elrich and his mother lived at 923 North Alfred Street until urban renewal took over the area. A devout Catholic, Elrich attended St. Joseph's Catholic School in Alexandria and later Armstrong High School in

Above: Elrich William Murphy. *Photo courtesy of Rita Murphy Harris, East Brunswick, New Jersey.*

Opposite: Elrich William Murphy, photographer. *Photo courtesy of Rita Murphy Harris, East Brunswick, New Jersey.*

Washington, D.C. He was described as a mesmerizing Latin dancer who loved the merengue and the bolero.

Murphy married Marie Elizabeth Henry in 1944, and they had a daughter, Rita Murphy Harris. The marriage ended in divorce, and Elrich never remarried. He was a Mason, and he also served as an usher at Saint Joseph's Church until his health declined. During his career as a photographer, he was also employed for sixty-two years by the religious supply company of William J. Gallery as a buyer of religious merchandise, retiring in November 1992 at the age of eighty-three.

Mr. Murphy died March 31, 1993, in East Brunswick, New Jersey, where he had moved to live with his daughter, Rita, and her family. His son-in-law, Dale Harris, called him "Champ" because he was a champion in everything he set out to do. Mr. Murphy was very close to his grandson, also named Dale.

EDWARD LLOYD PATTERSON

May 13, 1909–February 16, 1979

Edward Lloyd Patterson spent most of his career as an outstanding educator in Alexandria. He was born May 13, 1909, in Petersburg, Virginia, where he attended the public schools and graduated from Peabody High School. He earned a BS from Virginia State College in Petersburg, where he was also initiated into the Nu Psi Chapter of Omega Psi Phi Fraternity. He later earned a master's degree from Columbia University in New York.

After teaching in Blackstone, Orange and Charlottesville, Virginia, he continued his teaching career at Parker-Gray High School in Alexandria. In time, he became vice-principal of Parker-Gray High School, then principal of Parker-Gray Middle School and, finally, director of staff relations and student activities of Alexandria City Public Schools until his retirement.

At heart, Patterson was a teacher, with emphasis on choral and band directing. His philosophy was, "I have mine, now let me help you get yours." So he purposefully introduced and helped implement the idea of going to college to Parker-Gray students. Through contacts at his alma mater, Virginia State College, Patterson was able to secure scholarships and financial assistance for many students.

Edward Lloyd Patterson, educator and community leader. *Alexandria Public School Archives/ Records, Alexandria, Virginia.*

Mr. Patterson (known to his friends as Pat) was gentle, strong and understanding, with a genuine interest in the welfare of others. He seemed to always side with the poor, the weak and the wronged. With a loving heart and a pleasing smile, he served others and faithfully discharged all spiritual and public trust.

As a youth, he joined Mt. Zion Baptist Church in Petersburg, where he got his musical start. In Alexandria, he joined Shiloh Baptist Church, where he directed the choir for a short time. He became a trustee of the church board, on which he served for many years until his death.

Mr. Patterson was active in many area civic organizations, including the Seminary Civic Association, the Alexandria Community Chest, the Health and Welfare Council, the Human Relations Council, the board of the Olympic Boys Club, the Jail Ministry, the Equal Employment Opportunities Commission, the Northern Virginia Urban League Advisory Board, the National Association for the Advancement of Colored People, the RSVP (Retired Senior Volunteer Program) Advisory Board, the Volunteers In Service To America (VISTA), the Hopkins House Board of Directors, the National Council of Jews and Christians and the Alexandria-Mt. Vernon

Jack and Jill. He was a charter member of the Psi Nu Chapter of the Omega Psi Phi Fraternity, receiving Psi Nu's first Omega Man of the Year Award. He was also honored with the Northern Virginia Urban League's first James L. Anderson Award for distinguished volunteerism to end racial and economic discrimination, as well as the Departmental Progressive Club's Community Service Award.

Mr. Patterson died on February 16, 1979. His memory is preserved through the Northern Virginia Urban League's E.L. Patterson Memorial Award in education and Psi Nu's E.L. Patterson Scholarship.

Chapter 2

BUSINESS

Today, Alexandria has fewer African American–owned businesses than it had during its entire history. African Americans can now shop and buy like everyone else if they have the money to do so. But not too long ago, they were unable to move freely and do business in Alexandria. Whether they had money or not, they were restricted by law and custom from shopping, living, worshipping or attending schools in places designated for whites only.

Under these "Jim Crow" restrictions, in the late nineteenth century, a substantial number of African Americans who had the financial means began to open up businesses to meet the demand for basic services for their fellow African Americans. Among those who undertook commercial enterprises in nineteenth-century Alexandria were draymen (cart drivers offering the equivalent of today's taxi, truck and moving-van services), basket weavers, shoemakers, blacksmiths, laundresses, seamstresses, butchers, grocers and other merchants who provided for the basic needs of their African American clientele. There were African American churches and ministers, laborers, seamen and an African American newspaper. Those late-nineteenth-century entrepreneurs gave way to the African American businesses and professionals of the twentieth century.

Race relations remained a problem for African Americans in the early twentieth century. As the minority population of Alexandria increased, the need for goods and services also rose. African Americans expanded their commerce into beauty shops, bakeries, restaurants, lunchrooms, grocery stores, boardinghouses, cemeteries, dress shops, mutual life insurance companies, clergymen, lawyers, midwives, doctors, hotel owners, teachers,

shoe repairmen, newspapers, clubs and benevolent and fraternal societies. In many ways, Alexandria's African American community was self-reliant when it came to providing the services its members needed.

Generations of creative and entrepreneurial African Americans saw this need for services not available in the white community as opportunity. The men whose lives we document in this chapter used their skills and risked capital to advance themselves and their families in the business world.

Leon C. Baltimore Jr. was the city's first licensed African American master electrical contractor from 1932 until he retired in 1976. He served the African American community in Alexandria and won large contracts in Alexandria and the District of Columbia from both white and black enterprises.

Nelson Greene is a successful businessperson who has owned the Greene Funeral Home since 1954. Mr. Greene was also active in his community in local politics and became a voice for African Americans through his advocacy for civil rights. He challenged the establishment in the community to hire African American workers.

John Wesley Jackson was known to his customers as "Baker" Jackson or "Pie" because he owned the bakery and was famous for his pies—both regular-sized and a specialty of small, saucer-sized pies he also made and sold. He operated the bakery from a property he purchased in 1917 at 1022 Pendleton Street. The building was part residence, part bakery and part rooming house. He provided his baked goods as a wholesaler to many Alexandria merchants, and his rooming house offered safe lodging to many a traveler in a time when most hotels refused to accommodate blacks.

Washington N. "Wash" Jackson was well known as the owner of the Hotel Jackson. He was the first African American owner of a large hotel, which was located on King and Peyton Streets. The Hotel Jackson was more than a hotel for the African American community; it was also a social haven, a meeting place and a political gathering place.

John T. Martin Jr. was a third-generation shoemaker in Alexandria. The Martin family provided shoemaking and repair services to city residents for more than ninety years. Some Alexandrians still remember going to Mr. Martin's shop.

Samuel Appleton Tucker made his fortune in a real estate enterprise that established him as one of the richest African American men in Alexandria during that period. He also earned a degree in law but did not practice it.

These entrepreneurs left their marks on Alexandria for future generations to build on. Their biographical narratives attest to their humble beginnings but also prove that they excelled in choosing and developing successful careers.

LEON C. BALTIMORE JR.

December 28, 1910–March 26, 1994

Leon C. Baltimore Jr. was Alexandria's first African American licensed master electrical contractor and a respected member of the city's business community from 1932 until his retirement in 1976.

Baltimore was an enterprising businessman who owned a radio repair shop, Leon's Service Shop (also known as Baltimore Radio Electric), at 600 South Washington Street, which he opened in 1932. Three of the larger contracts won by the shop included the installation of the first public address system in the Alexandria City Council Chambers, sound systems for the Capital Theater and setting up amplification for the Daughters of the American Revolution's wreath-laying ceremonies at Mount Vernon, the estate home of our first president, George Washington.

He was also an active participant in the civic life of Alexandria, where he was born on December 28, 1910. Baltimore was elected as the first treasurer of the Alexandria chapter of the National Association for the Advancement of Colored People when it was organized at a meeting at Alfred Street

Baptist Church in 1933. The group received its charter in 1934. He was a founding member of the Hopkins House Association, a charitable organization providing childcare and other services to African American families in Alexandria, when it was organized in 1939. His name appears among the list of Alexandria African Americans registered for the draft during World War II.

Leon C. Baltimore Jr., businessman. *Photo courtesy of Ann Baltimore Flye, Alexandria, Virginia.*

Leon C. Baltimore Jr. and his wife, Evelyn Day Baltimore. *Photo courtesy of Ann Baltimore Flye, Alexandria, Virginia.*

Mr. Baltimore was married to the former Evelyn Day, with whom he had a daughter. He was a member of Roberts Chapel (now Roberts Memorial United Methodist Church), where he served on the board of trustees and sometimes played the organ. Mr. Baltimore died in Alexandria on March 26, 1994. He was survived by his wife, Evelyn D. Baltimore, who died in 1999, and his daughter, Ann Baltimore Flye.

NELSON GREENE SR.

Born May 20, 1914–

Nelson Greene Sr. has made an enormous impact on the progress of civil rights and equality of opportunity in Alexandria. He was a member of the Secret Seven, a group of African American activists who worked—often behind the scenes—to help integrate Alexandria, particularly during the 1950s and 1960s, countering Virginia's "Massive Resistance" against integrating

Nelson Greene Sr., businessman and community activist. © *Living Legends of Alexandria. Photo by Nina Tisara.*

the schools. Mr. Greene was also active in the National Association for the Advancement of Colored People and worked across the board for civil rights issues and equal access to housing and city facilities. He took the initiative in fighting for job opportunities, lobbying city council and working to make sure the City of Alexandria hired blacks in other than menial positions. He also persuaded storeowners and other businesses, including the bus company, to open hiring for black people.

Mr. Greene was elected to the Alexandria City Council, serving from 1979 to 1982. He was just the second African American since Reconstruction to serve on the council. Mr. Greene said his time on council was at first rather difficult: "I was not really accepted until I got into the operation of the council. I kept a lot of things before the city that otherwise would not have arisen. They were so used to how it used to run, and I brought change. It caused a lot of confusion, but it turned out in a good way."

Nelson Greene Sr. was born in Danville, Virginia, on May 20, 1914. He moved to Alexandria in 1953 and established the Greene Funeral Home in 1954, having worked in funeral homes in Danville and Martinsville prior to that. The business is located at 814 Franklin Street, where he still resides in the family quarters with his wife, Gloria Kay Greene. The couple has two sons, Nelson Jr. and Terry Franklin. He is a member of Meade Memorial Episcopal Church.

Mr. Greene graduated from Shaw University in Raleigh, North Carolina, in 1941 with a major in economics and a minor in chemistry. He served in the U.S. Army in World War II and then went to Officer Candidate School and volunteered for service in Korea, reaching the rank of major.

Of his public service in Alexandria, Mr. Greene said, "It was a hard system to buck. We had to overcome a lot of things that had been going on for years." Working with other activists, he strove successfully to change the system of the schools and of daily living in the city. "The entire system has gotten a lot better," he said in a December 2011 interview. "The community, the educational system, the religious system—it's all a lot more open."

His advice to young people today, he said, is to take part in the city: "Act, whether you like it or not. Take part in everything a citizen does." He pointed out that for earlier generations, this was not possible—that blacks could act only in their own environment and not the wider community. Among other activities in his long life, Nelson Greene taught math at Parker-Gray School as a substitute teacher. His wife, Gloria Greene, was also a longtime schoolteacher in Alexandria City Public Schools.

Reflecting back on his life, Mr. Greene said, "What you plan doesn't always work. There's a lot of luck that goes along with it." "I never thought

I'd live to be ninety or more," he added. Greene's granddaughter, Nina, who helps run the funeral home now, said her grandfather's advice to her when she said she wanted to work for the family business was, "There are no girl jobs here; there is only work." Nina is the daughter of Nelson Greene Jr., who currently manages the firm. Nelson Jr. is also a former member of the Alexandria School Board.

On Christmas Day 2011, the Greenes celebrated their seventieth wedding anniversary. They were married in Raleigh, North Carolina, on December 25, 1941, with the bride in white satin and the bridesmaids in red velvet, Nina said.

Nelson Greene has been a respected role model and mentor to other leaders in Alexandria for all the years he has lived here and served his city. He was named a Living Legend of Alexandria in 2010.

JOHN W. "BAKER" JACKSON

January 15, 1874–February 6, 1949

John W. Jackson was the owner of the Alexandria Home Bakery, located at 1022 Pendleton Street at the corner of Henry Street in Alexandria. He purchased the property in 1917 and obtained a license for it as a rooming house, permitting the bakery to serve a dual purpose in Alexandria's African American community. In 1917, the only hotel in Alexandria for African Americans was owned by Washington Jackson. The Hotel Washington was destroyed in 1927 after a tornado, and Alexandria's George Mason Hotel was for a white clientele only. For many years after that, the Pendleton Street side of John Jackson's building served as a rooming house. During that time, it was the only site to support African American travelers and chauffeurs passing through Alexandria. The Henry Street side served as the bakery.

John W. Jackson, known as "Baker," delivered goods from his bakery at wholesale prices to various Alexandria merchants. Mr. Jackson was known for his doughnuts, wedding cakes, cookies and pies (lemon, apple, peach and sweet potato). Many older Alexandria residents have fond memories of consuming the fine pies, cakes and pastries that proved his skill as a baker. Baker Jackson, who also worked for a time for a white baker at West and Cameron Streets, kept the bakery until the time of his death. After his

Above: John W. Jackson's residence and business, Alexandria Home Bakery, at 1022 Pendleton Street (corner of Henry Street). *Photo courtesy of Corrine Dixon, Alexandria, Virginia.*

Left: John W. "Baker" Jackson, businessman. *Photo courtesy of Janice Howard, Alexandria, Virginia.*

death, the family converted it to a deli, selling soup and sandwiches. The property remains a rooming house to this day and is run by Jackson's only surviving child, Corinne Jackson Lee Dixon, who was born on the site, and her daughter, Janice Lee Wardlaw Howard. Ms. Dixon remembers that her father was also known to some as "Pie" Jackson, for the smaller, saucer-sized pies he made and sold to retailers for three cents wholesale. The retailers then sold them to individuals for a nickel.

Mr. Jackson was born in Johnson City, Tennessee, on January 15, 1874. After two earlier marriages, about which little is known except that there were two children from the first one, Jackson married his third wife, Corinne. The couple had four children, one of whom died as an infant. Jackson emphasized education to his children. Daughter Corinne said that she and her siblings all attended Parker-Gray Elementary School and then Dunbar High School in the District of Columbia in the time before Alexandria had a high school for African American children. Her father, she recalls, drove his children into D.C. every morning, from the time they were in the ninth grade right through the twelfth grade, from his home bakery to the school. She remembers their car as a 1933 Chevrolet, in which he also picked them up for the return trip home in the afternoon.

Mr. Jackson died in Alexandria on February 6, 1949. His property at the corner of Pendleton and Henry Streets is of historic significance to Alexandria's African American community. His three surviving children inherited the property at his death. Daughter Corinne and granddaughter Janice bought out Corinne's siblings, and they have maintained the property over the years as part of Alexandria's African American heritage.

WASHINGTON "WASH" JACKSON

1856–February 19, 1939

Washington N. Jackson, known as "Wash," was the owner of the first large hotel serving the black community in Alexandria. The hotel, located at the corner of King and Peyton Streets, served many African Americans visiting the area and was also a lodging place for African Americans who did not have a permanent place to live. The hotel was

a site where black civic organizations could meet and hold conferences. Jackson's hotel was, for example, the location for the fortieth anniversary celebration of Lincoln's emancipation proclamation. In 1905, the local branch of the National Negro Men's Business League used the Hotel Jackson as the venue for its meeting. Sadly, the hotel was destroyed by a tornado in 1927.

Mr. Jackson was born in slavery in Loudoun County, Virginia, in a time when record keeping regarding slaves' lives was limited. As a result, we do not know the exact date of his birth. Wash Jackson rose to prominence and held leadership positions in Alexandria. Prior to becoming a hotel owner, he was a merchant, and in the period around 1885, he owned a grocery store at 200 North Payne Street.

In his lifetime, Jackson became a trustee of three Alexandria churches: Shiloh Baptist Church, Mt. Jezreel Baptist Church and Third Baptist Church. When Shiloh Baptist Church hosted the conference of the colored Republicans Congressional District of Virginia, Jackson presided over the meeting, and William A. Carter was the secretary. It was Mr. Jackson who announced the organization's endorsement of Lieutenant Colonel Theodore Roosevelt for president at Shiloh Baptist Church. He was a member of the National Building Association of Baltimore and of the Alexandria Chapter of the National Association for the Advancement of Colored People. He owned stock in several associations and acquired large real estate holdings in the city of Alexandria.

Obtaining bank loans was difficult for many African Americans in Alexandria during this time. As a more prosperous person, Washington Jackson became a lender to those African Americans who could not secure loans from a bank.

Mr. Jackson was married to Elizabeth Lucas on September 8, 1885. His second wife, whom he is believed to have married in the late 1920s, was named Mildred. Jackson died at his home at 429 North West Street in Alexandria on February 19, 1939. His funeral took place on February 20 at Third Baptist Church in Alexandria. In his will, he left to the trustees of Third Baptist Church the shares of stock he owned in the Colored Fair Association of Fairfax, Virginia. He also left money to eighteen individuals, including his wife.

JOHN T. MARTIN JR.

February 24, 1904—March 22, 1967

John Theophilus Martin Jr. was a third-generation shoemaker and repairer who learned the family business from his father, John T. Martin Sr., who had learned shoemaking from his father, George Washington Martin.

John T. Martin Jr. was born in 1904 in Alexandria to John T. Martin Sr. and his wife, the former Fannie M. Kyer. The family lived at 626 South St. Asaph Street. His early education was at Snowden and Parker-Gray Schools. John T. Jr. was one of three children, but only he and his sister, Nellie Martin Greene, lived to adulthood.

John worked side by side with his father, first at their home at 626 South St. Asaph Street. Then John Sr. built an eight-room house at 521 Gibbon Street and located his shoemaker's business next door at 523 Gibbon Street. Together, father and son worked at the shop until John Sr. died on November 27, 1943. John Sr.'s wife, Fannie, had died two years earlier.

John T. Martin Jr. continued to run the family business until a few years prior to his death, and some older Alexandrians still remember him as the "shoe and repair man." He was married to Margaret Martin, and their daughter, Theola Martin Chambers, lived in Alexandria until her death in 2012. Their son, Norman Martin, died in 2011 at age eighty-five.

Shoemaker John T. Martin Jr. died on March 22, 1967, and is buried near his parents and sister at Bethel Cemetery in Alexandria.

SAMUEL A. TUCKER

June 1, 1884–February 1965

Samuel Appleton Tucker ran a real estate business in the Alexandria African American community in an office at 901 Princess Street. He shared the office space with his friend Thomas Watson, a practicing attorney. Mr. Tucker had attended law school in the District of Columbia and earned a law degree but never practiced. He needed to be able to provide for his family, and practicing law in his community at that time was not lucrative.

Tucker rented and sold property as a real estate broker, while Watson served as a lawyer for colored people in need.

Tucker built his business from humble beginnings, originally working as a coachman for Dr. George T. Klipstein in Alexandria. He not only drove the doctor but also collected rents for him. For his faithful service, he was rewarded with generous gifts of property in Klipstein's will when the doctor died. From that legacy, Mr. Tucker began renting and selling property all over Alexandria. It was said that Tucker became one of the wealthiest African American landowners of his time. Tucker served as senior deacon, Sunday school superintendent and senior choir director at Zion Baptist Church— the church that his parents had helped to start. He was a 33rd Degree Mason.

Samuel A. Tucker was born June 1, 1884, on Lee Street in Alexandria, the son of Albert Tucker and his wife. He is the descendant of William Tucker, who is said to be one of the first African American babies born in the state of Virginia. Samuel A. Tucker married Fanny Williams from Midland, Virginia. They lived at 916 Queen Street in the home Samuel and his father built for the new bride. Samuel and Fanny had four children: George David, Samuel Wilbert, Otto Lee and Elsie Virginia.

Later in life, Tucker lived in the Alexandria neighborhood of Sunnyside with his daughter Elsie Virginia and her husband, William Thomas, and their two children, Deborah and William. Mr. Tucker continued to go to his office every day until he was eighty years old. He died in 1965 at the age of eighty-one.

CIVIC AND COMMUNITY ACTIVISM

In the twentieth century, the city of Alexandria experienced a wave of African American activism in politics, civic and national organizations, schools and churches. The need for community leaders was great during the segregation years, which lasted until the civil rights movement brought down the Jim Crow laws in the 1960s.

The accomplishments of eighteen individuals in the area of community activism are highlighted in this book. Their contributions and achievements made a difference in Alexandria and often farther afield. Many in our community benefited from their leadership and involvement.

Harry S. Burke was an educator and an advocate for the recording, recognition and teaching of African American history. As a young man, he had been a competitive swimmer, and as an adult, he engaged the community in his passions for education, African American history and water sports, working through numerous organizations and serving on the boards of many committees.

Connie Belle Sitgraves Chissell was one of the nine founders of Alexandria's Hopkins House Association and became the first director of the Hopkins House in 1939. Mrs. Chissell was responsible for opening the first African American public daycare and after-school care center for children in Alexandria.

Ferdinand T. Day is still an icon among Alexandria's civic leaders, both black and white. He has given more than seventy years of his life to his beloved city. Mr. Day was the first African American appointed to the

Alexandria School Board. He was instrumental in achieving the integration of the Alexandria City Public Schools, and he has been a strong voice for the African American community on race, education and housing issues.

Helen Lumpkins Day was a schoolteacher in the upper grades in Alexandria during the years of segregation and later in the integrated public school system. She was active in the community outside of school as well, holding leadership roles in several associations and committees. She, too, was among the founders of the Hopkins House Association.

Lawrence D. Day was a charter member of the inclusive African American Departmental Progressive Club, which was started in 1927. He held leadership roles in several organizations, including the Alexandria Slum League, the National Association for the Advancement of Colored People and the Boy Scouts of America.

James Oliver Fortune was a janitor at the Parker-Gray School, which later became Parker-Gray High School. His act of bravery, altering the name of the new high school by painting out the word "Negro" on the wall of the school, changed the history book for Parker-Gray. In the African American community, Mr. Fortune was recognized as an agent of social change.

Blois Oliver Doles Hundley was a champion for civil rights in her community. In 1958, she sued the Alexandria School Board for preventing her children from being admitted to a previously all-white school. She and her colleagues won their case, though it cost Mrs. Hundley her job.

Eudora N. Lyles was a community champion and organizer. She was the organizer for the Inner City Civic Association to fight against the destruction of two hundred homes in her neighborhood to make way for an eight-lane highway. After seven years of fighting, she and others won their case.

A. Melvin Miller has served on the Alexandria Redevelopment and Housing Authority for many years. He also contributed to the civil rights movement by providing his legal services pro bono to civil rights activists. He has served on many boards and organizations in Alexandria.

Helen Anderson Miller was an activist on many fronts. She was one of the first forty-five members of the Alexandria Economic Opportunities Commission, and she also helped to start a daycare center. She was an active participant in many other organizations, including the Boys and Girls Club, the Mothers Club, the Martin Luther King Memorial Commission, the Black Heritage Committee, the Parker-Gray Alumni Commission and the Urban League Forum.

Arthur Nelson was one of the first African American letter carriers in Alexandria, a job he held for thirty-eight years. An active member of the Departmental Progressive Club, he also belonged to Elks Lodge No. 48 for

fifty years, during which time he helped institute several community projects through the Elks organization.

Mary E. Randolph was a cafeteria worker in Alexandria City Public Schools and a pianist for her church and community. Through Ms. Randolph's last will and testament, the community learned of her great generosity. She gave over $300,000 to Alexandria's churches and the organizations and individuals that served the Alexandria African American community.

Katie Nelson Skinner was the founder of the first Alexandria African American Red Cross Volunteers, known as "The Grey Ladies." She also held membership in the Bethune Branch of the Young Women's Christian Association and served on the boards of directors of the League of Women Voters and the American Cancer Society.

John A. Stanton was an active community leader who founded the Alexandria African American Olympic Boys Club. He served on the boards of directors of the Alexandria Hospital, Hopkins House Association, the Commission on Aging and the Alexandria Red Cross.

Elsie Charity Taylor Jordan worked in the Alexandria Sheriff's Department, where she initiated procedures to achieve racial diversity in the workplace. She fought against drug addiction and helped to start the first methadone program in Alexandria.

Robert Isaac Terrell was serving as president of the NAACP during the turbulent years of the civil rights movement to desegregate public facilities. He worked with the mayor of Alexandria on a biracial committee to desegregate Alexandria merchants in 1960. He asked Alexandria's commonwealth's attorney to investigate the killing of an African American man in the city in 1961.

Ruby J. Tucker channeled her activism into programs that served children. She taught at the preschool of the Alive Child Development Center for ten years and was the center director for twelve years. She was a PTA president at numerous schools attended by her children and foster children and co-founded a number of programs for children.

Dorothy Evans Turner was a pioneer in advocating for the rights of public housing residents in Alexandria. Ms. Turner advocated for African American representation on the city council and on the Alexandria Redevelopment and Housing Authority and continues to advocate for minorities today.

These dedicated community leaders stood for justice and equality for all Alexandrians. The stories of their lives attest to their dedication and effectiveness as civic activists.

THE BROOKS FAMILY

All five children of the Reverend Houston G. Brooks Sr. and his wife, Evelyn Lemon Brooks, attended Parker-Gray High School. They lived in the Sunnyside area in northern Alexandria. The Brookses motivated their children to strive for academic success no matter the obstacles. All the children graduated from Parker-Gray High School, went on to graduate from college and then earned graduate degrees. They achieved distinguished careers in our nation, demonstrating that success is more about personal commitment than about the stumbling blocks along the way. Their individual narratives are divided among various chapters of this book, according to their interests. (See the chapters on science, religion and the military.) One daughter, Nellie Brooks Quander, became a schoolteacher, a principal, a curriculum coordinator, president of the National Association of Elementary School Principals and a member of the Virginia State Board of Community Colleges. One son became a minister and professor of psychology and theology, while two others focused on science—one as a researcher and developer of patents and the other as a high school teacher who later became a state legislator. The fourth became a general in the United States Army.

HARRY S. BURKE

October 21, 1925–

Harry Burke is a native Alexandrian who has lived in the city all his life except for his time serving in the U.S. Army and at college. An educator who retired as media director for the Washington, D.C. public school system, Burke was also a longtime mentor for student swimmers in Alexandria. After his retirement in 1983, he was able to devote more time to his lifelong passion for African American history. He dedicated many years to ensuring that Alexandria became more aware of the history of its African American residents and that this knowledge was widely shared and publicized. An active member of the Alexandria Society for the Preservation of Black Heritage, Inc., he was instrumental in the founding of the Alexandria Black History Resource Center that opened in 1989 in the former Robert

Robinson Library. He also actively worked to ensure the establishment of the African American Heritage Park.

Burke was born on October 25, 1925, in Alexandria to Rozier and Hollie Harris Burke. He graduated from Parker-Gray High School in 1943 and then served in the United States Army from 1943 until 1946. He graduated from Hampton Institute (now Hampton University) in 1950 and then returned to Alexandria. In 1960, he earned a master's degree in education (industrial arts) from the University of Maryland. At Hampton, he had been a competitive swimmer and over the years often used his connections there to help African American youth in the city obtain scholarships to the Institute.

Mr. Burke was also a member of the Alexandria City Public Schools' Vocational Advisory Board. He was aquatic director of the Water Safety Institute from 1951 to 1972. From 1956 to 1980, he chaired the board of the Alfred Street Baptist Church. He served on the board of directors of the city's DASH transit system and was president of the Church and Fraternal Cemetery Association of Coleman Cemetery. In 1990, he received the Community Service Award from Hopkins House. He is a past president of the Seminary Civic Association.

Mr. Burke and the former Costella Grant have been married for more than sixty years. They have a daughter, Hollie, and a grandson, Douglas Joiner III.

Mr. Burke is fondly remembered as a summer pool director at the city's Johnson Pool, where he supervised not only swimming and water safety but also water shows, cookouts, parties and all manner of summer fun. He was a builder of community spirit and an inspiration to many.

CONNIE BELLE S. CHISSELL

July 6, 1901–October 7, 1992

Mrs. Connie B. Chissell was a founding member and longtime director of the Hopkins House Association in Alexandria.

In the late 1930s, Mrs. Chissell, Edith L. Allen, Helen Day, Leon C. Baltimore Jr., Margaret Evans, Samuel W. Madden, Richard Poole, Alma P. Murray and Evelyn Johnson Williams formed the Hopkins House Association and in 1939 established Hopkins House. Because there were

no government funds, the founders of Hopkins House volunteered their services to a daycare nursery and after-school programs. Hopkins House was then able to receive funding through the Community Trust (known today as the United Way) to operate the facility for children.

Mrs. Chissell was elected as the first director of the Hopkins House, serving from 1939 to 1952. During her tenure, the association set up an African American library, provided a meeting space for the Alexandria Chapter of the National Association for the Advancement of Colored People (NAACP), offered activities for the Society for the Prevention of Delinquency, set up an employment clearinghouse for African American veterans of World War II and established a scholarship fund for graduates of Parker-Gray High School. Members also worked with the city to convert the nearby closed USO building to a recreation center for black children. This center provided shop classes, recreation, after-school programs, sewing and cooking classes and a welcoming place for children who were hungry or would otherwise have been home alone, often in unheated homes in winter.

Connie Belle Sitgraves was born on July 6, 1901, in Rock Hill, South Carolina, to Major and Ardoshar (Docia) Barber Sitgraves. She graduated in the 1920s from Wilberforce University in Ohio with a degree in business administration. She married Dr. Herbert Garland Chissell in Tennessee on October 28, 1921, and the couple had three children. Two sons, John T. Chissell and H. Garland Chissell Jr., both became doctors like their father. Their daughter, Connie Chissell (later Connie Chissell Young), graduated from Parker-Gray High School at the top of her class at age fifteen. She earned a BA from Fisk University, graduating first in her class.

In the early 1950s, Dr. Chissell suffered a stroke at their home on North Fayette Street. They moved to Baltimore, Maryland,

Above: Connie Belle Chissell on a forty-one-day Mediterranean and Near East Cruise in 1964. *Photo courtesy of Mark Young.*

Opposite: Community leader Connie Belle Chissell as a young adult. *Photo courtesy of Mark Young.*

to be near their sons. Mrs. Chissell became the caregiver of her husband until his death in 1957. After his death, she spent the rest of her time with her children and grandchildren. Connie Sitgraves Chissell died in Baltimore in 1992 at the age of ninety-one.

Mrs. Chissell was an exceptional woman for her time. Most college-educated women in the early twentieth century majored in education, but Mrs. Chissell majored in business administration. Unlike other African American women during that period, she could afford a housekeeper when she began working outside of the home. She homeschooled her daughter prior to enrolling her in public school, setting a foundation that enabled her daughter to excel.

Mrs. Chissell was a visionary who saw the needs of the African American community and acted to help meet them. After more than seventy years of serving the community, the Hopkins House is still providing those basic needs on the foundation that Mrs. Chissell and the early founders built.

FERDINAND T. DAY

August 7, 1918–

Ferdinand T. Day has spent his life being a civic leader, an example and a role model in Alexandria, the Virginia city in which he was born on August 7, 1918. Ferdinand Day was the first black chairperson of the Alexandria School Board, as well as the first African American to chair a public school board in Virginia. He was instrumental in the integration of T.C. Williams High School and its football team. Day also served on the board of the Northern Virginia Community College and the Virginia State Board of Community Colleges, where he was also vice-chair. In 1985, he was selected by the Secretary of Education to assist in the further implementation of the Virginia desegregation plan for higher education.

Mr. Day attended Parker-Gray Elementary School and graduated from Armstrong Technical High School in Washington, D.C., in 1935. In his youth, there was no high school for African Americans in Alexandria. He earned a BS in geography and history from Miner Teachers College in the District of Columbia.

Mr. Day's professional career was spent with the U.S. Department of State, from which he retired in 1978. He was also very involved in community

Ferdinand T. Day, community leader in education, civil rights activist and federal government employee. © *Living Legends of Alexandria/Photo by Nina Tisara.*

activities in Alexandria. In addition to his school board and community college board service, he was a Boy Scout leader and a member of the Hopkins House Board, the Departmental Progressive Club, the NAACP and the Secret Seven, a dynamic group of black men who worked toward civil rights and the integration of schools and other public institutions in Alexandria. Mr. Day said that in his youth, there were "many injustices and shameful wrongs to be corrected. Most of the problems then inherent in the Deep South were prevalent here in Alexandria."

Day has received awards for outstanding community service from many organizations, including the Alexandria City Council, Alexandria Olympic

Boys and Girls Club, Alexandria Public Schools, Alpha Kappa Alpha Sorority, Omega Psi Phi Fraternity, the Departmental Progressive Club, the Elks Lodge, the NAACP, the Northern Virginia and Washington Urban Leagues, the Virginia Community College System, and the U.S. Department of State. In 2007, he was honored as a Living Legend of Alexandria.

Mr. Day, now widowed, was married for sixty-one years to Lucille Peatross Day. He resides in Alexandria with his daughter, Gwendolyn Day-Fuller. He has two grandchildren, William Fuller and Shanna Ringer, and three great-granddaughters, Imani Fuller, Chloe Fuller and Brianna Ringer, all of whom reside in Massachusetts. He is a lifelong member of St. Joseph's Catholic Church.

HELEN LUMPKINS DAY

July 4, 1905–June 1, 1992

Helen Lumpkins Day touched many lives in Alexandria, both as a teacher in the upper grades of Alexandria City Public Schools and as a leader in social, cultural, educational and political organizations. In 1992, President George Bush signed a bill that officially renamed the main Alexandria Post Office at 1100 Wythe Street the Helen L. Day Post Office.

Born in Alexandria, Virginia, on July 4, 1905, Helen became a member of Roberts Chapel Methodist Episcopal Church at an early age. She served in many capacities in her church, but her first love there was the Junior Choir.

After attending the Hallowell School for Girls in Alexandria, Helen Lumpkins graduated from Dunbar High School and Miner Teachers College, both in Washington, D.C. She was active in the community she loved and was a source of great strength and leadership through her commitment to public service. She taught in Alexandria schools for forty-six years. She was one of the founders (1939) of the Hopkins House Association, where she was active in the fundraising and program development of a preschool daycare facility for the children of African American working parents in what was then still a segregated city. She had a particular concern for helping the poorest families.

Mrs. Day was active in the Mental Health Association of Alexandria, the League of Women Voters, the Margaret Evans Federated Club, the

From left: Welton and Nellie Brooks Quander, Nelson and Gloria Greene, Lawrence and Helen Lumpkins Day and Lucille and Ferdinand T. Day at a Departmental Progressive Club social. *Photo courtesy of Lawrence P. Robinson.*

Council of Social Agencies, the Alexandria Retired Teachers Association, the Alexandria Tuberculosis Association, the American Red Cross, the Girl Scouts of America (she formed Brownie Troop No. 8), the National Association of Colored Women, United Way Washington Metropolitan Area and the Psi Gamma Mu Sorority. The Helen L. Day Preschool Academy at Hopkins House was named in her honor.

Mrs. Day was married to Lawrence D. Day, and the couple had a daughter, Bernice. Mrs. Day died in Alexandria on June 1, 1992. She was survived by her husband (who died in 2000); her daughter, Bernice; her son-in-law, Harold Lee; two granddaughters; and three great-granddaughters.

LAWRENCE D. DAY

March 19, 1911–October 23, 2000

Lawrence Day was a charter member of the Departmental Progressive Club, an organization he dearly loved and in which he was known by most as "Mr. Departmental," having served as president for twenty terms.

Lawrence Day was born in Alexandria on March 19, 1911. He was baptized at St. Joseph Catholic Church at a very early age and was an active participant in the church. He attended Snowden and Parker-Gray Schools in Alexandria and graduated from Armstrong High School in Washington, D.C. As a teenager, he found employment with the federal government, where his career with the General Accounting Office spanned forty-four years. Over the years, he rose from messenger to chief of the Transportation Division.

After retiring from the federal government, Day served for ten years as a magistrate for the City of Alexandria.

Lawrence Day's leadership positions in the community included service on the Alexandria Slum League, the National Association for the Advancement of Colored People, the Boy Scouts of America, the Boys Club, the steering committee for the establishment of the Robert Robinson Library and Senior Citizen Services.

Lawrence was married to Helen L. Day, who died in 1992. Lawrence died in Alexandria on October 23, 2000. He is survived by a daughter, Bernice; son-in-law, Harold H. Lee; two granddaughters, Dr. Carol Lee Collins and Dr. Helen Lee Virgil; three great-granddaughters; and three nieces.

JAMES OLIVER FORTUNE

July 14, 1884–June 2, 1963

James Oliver Fortune proved that status in life need not limit a human being's impact on his times. Mr. Fortune, who had been a driver earlier in his life, was a janitor at Parker-Gray High School during the tenure of Principal Wesley D. Elam in the 1930s. During this time, Parker-Gray, which had been an elementary school, became a high school. In celebrating that transition,

the City of Alexandria renamed the school Parker-Gray Negro High School. The new name was installed on the school building. Mr. Fortune put his job on the line by climbing a ladder to paint out the word "Negro." Through this act of courage, he risked losing his job and upsetting the status quo.

To the students of Parker-Gray High School, that act made James Fortune a hero. More than seventy years later, former Parker-Gray student Lucian Johnson said that Mr. Fortune changed the history of the school forever by having the courage to paint out the word "Negro" from the name given to the school by the Alexandria School Board. The students believed that by deleting the word, Mr. Fortune sought to prevent them from being stigmatized as inferior to those in white schools.

Fortune was born July 14, 1884, in Westmoreland County, Virginia, to Thomas and Mary Byrd Fortune. He had several siblings, but only one of them, Isaiah Fortune, lived in Alexandria. When Isaiah died at Freedmen's Hospital in Washington, D.C., on December 24, 1958, his obituary stated that his only surviving sibling was James O. Fortune. Isaiah's funeral took place at St. John's Baptist Church.

James Fortune was married twice. He and his first wife, Rebecca, had a child named Thelma. After the death of Rebecca, he married Maggie (Mattie), and they had one child, Virginia.

James Fortune registered for the draft for both World War I and World War II. On his 1918 draft card, his address was listed as 320 South Columbus Street, and his occupation was given as driver. His 1942 draft card listed his address as 327 North West Street and his employer as the City School Board of Alexandria, Virginia.

Mr. Fortune died on June 2, 1963, at Alexandria Hospital. His funeral took place in his place of worship, St. John's Baptist Church. His granddaughter Arlett remembers him as "an ordinary man that was well liked by many people and devoted to his church."

BLOIS OLIVER DOLES HUNDLEY

September 21, 1914–January 13, 2008

Blois Hundley was a pillar of her community and a parent who worked as a school cook and who, along with other parents, courageously filed a federal

lawsuit in 1958 demanding that their children be admitted to previously all-white schools. On February 4, 1959, Judge Albert Bryan ordered the defendant, the Alexandria School Board, to admit nine Negro plaintiffs to three schools. During this process, Alexandria City Public Schools fired Mrs. Hundley after learning that the school employee had been a plaintiff in the suit. In February 1959, the children entered the schools without incident. A Freedom of Choice plan was developed to authorize such admittances; however, the plan was little known and little used.

Blois Oliver Doles was born in Southampton County, Virginia, the eldest of four children, to James Oliver and Edith Doles. She and her brothers—James, Curtis and Mayo—were raised by their maternal grandparents. At an early age, she learned to cook very well and to bake delicious, prize-winning rolls that her grandfather would sell from his truck to the workers in town for lunch.

When Blois was fifteen, both grandparents died within one week, and she moved to New York to live with relatives. While there, she met and later married Clarence Carter. Two sons, Clarence and Calvin, were born of that marriage. She later moved to Alexandria, where she spent most of her adult life. She married the late Pervis A. Hundley, and six daughters were added to the family: LaJeune, Dollie, Theodosia, Pearl, Barbara and Pervinia L. Raising eight children limited how much Mrs. Hundley could work outside the home, but her skill for cooking landed her jobs in several fine restaurants, the public school system and private homes. This courageous woman, who advanced the cause of integrated education at considerable personal sacrifice, died at Gilcrist Hospice Center on January 13, 2008.

ELSIE CHARITY TAYLOR JORDAN

August 26, 1926–

Elsie Charity Taylor Jordan was very active in her community, church and politics. In 1970, she was working as a deputy in the Alexandria Sheriff's Department when she became a matron for the women inmates at the Alexandria City Jail on Princess Street. She was promoted to sergeant and then became the personnel analyst for the department. In that capacity, she initiated efforts that led to more diverse demographics in the recruiting and

hiring policies of the department. In 1975, she transferred to city hall, where she worked as a personnel assistant until her retirement in 1988.

Ms. Elsie, as she was known, played a vital role in bringing about social change in the city of Alexandria, often challenging city council members, the mayor and other officials when she believed the city fell short in its handling of social issues. On the occasion of her sixtieth birthday, she was honored by a proclamation from the mayor and the City of Alexandria.

Ms. Elsie worked diligently to fight against drug addiction in the city. She was instrumental in establishing the first methadone program at the Alexandria Health Department. Through this program, many who were addicted to drugs were treated, became clean and established themselves as productive citizens of the community. In 1989, she testified before the U.S. Senate Special Committee on Aging on the effects of the crack epidemic on seniors who ended up caring for crack babies born to their children and grandchildren because the young people were irresponsible parents due to their addiction. She also worked with Virginia senator Wiley Mitchell to petition the state for more drug rehabilitation programs as an alternative to jail time.

As part of her advocacy for seniors of Alexandria, Ms. Elsie developed and directed the Crunch Bunch, a program for senior citizens that still operates at the Charles Houston Recreation Center. During its early days, she provided lunch and special activities for the seniors through the Hopkins House Association. The program also assisted seniors who needed help getting to medical appointments or going shopping.

Ms. Taylor was appointed to the Alexandria Community Corrections Board in 1994. She was a co-founder of the Community Action Team (CAT), which worked under the direction of the Alexandria Police Department to help quell violence in the city during times of community unrest by keeping youth off the streets and out of trouble. Among her awards is the Medal of Valor from the Alexandria Police Department. She also received the Mary Church Terrell Award from the National Association of Blacks in Criminal Justice.

As a social worker for the Hopkins House Association, Ms. Elsie helped ensure that citizens in the community had shelter, food, health care and other necessities. Her special interest in young people led her to give assistance and encouragement to many. Through her teaching and example, they learned the value of education and self-worth. She taught them to aspire to do their best, encouraging many to go on to become successful in business and achieve leadership positions in their communities. She also received a letter of appreciation from former governor Douglas Wilder for her work on the development of Potomac Yards.

Elsie Charity was born in Alexandria, one of the twelve children of Rozier and Maggie Charity, originally from Upperville, Virginia. Elsie graduated from Parker-Gray High School. After high school, she married her high school sweetheart, Gerald Carleton Thomas, who predeceased her. Later, she met and married Llewellyn Taylor, and the couple resided at 1601 Princess Street and, later, on Wilson Avenue. After the death of Mr. Taylor, Elsie married Edwards Jordan. Ms. Taylor is the mother of seven children: Vernie (deceased), Geoffrey, Becky, Liz, Kim, Polly and Sandy. She is also the grandmother of twenty-one, the great-grandmother of twenty-nine and the great-great-grandmother of two.

In her youth, Ms. Elsie sang in the Charity Sisters trio in local churches with her sisters Irene and Margie. She is a seventy-five-year member of Ebenezer Baptist Church, where she was an active leader of committees and organizations, a den mother for the Boy Scouts, president of the Gospel Chorus and founder and organizer of the Gospeliers, a group that is still singing after forty-four years. She was honored by the church as one of its "Sheroes." She still resides in Alexandria.

EUDORA N. LYLES

January 25, 1918–July 6, 2000

Eudora N. Lyles was a champion for Alexandria's minority residents who also worked to better the community for everyone. A resident of North Fayette Street, she founded the Inner City Civic Association. In 1972, zoning proposals threatened to wipe out the inner-city neighborhood in which she lived. The plan was for an eight-lane highway to come through the center of the north side of Alexandria. That plan would have taken over two hundred homes, mainly in the black community. Mrs. Lyles organized awareness meetings, formed the Inner City Civic Association and became involved with other civic associations to stop the plan. She wrote letters, made phone calls, attended city council and zoning meetings, gathered pertinent information, met with community leaders and led the seven-year fight to a victory for inner-city residents.

Mrs. Lyles was also co-chair of the Economic Opportunity Commission and a member of the board of Micah Housing, Inc., the Community

Eudora N. Lyles, community leader and civic activist. *Photo courtesy of Eudora Lyles Forrest.*

Development Block Grant Committee, the Martin Luther King Program Committee, the Black Caucus and the National Association for the Advancement of Colored People. She helped organize many voter registration drives and other voter education activities. Mrs. Lyles also worked on the United Way study on housing issues and was a member of the Tenants Organizing Project. In 1985, she won an award from the Alexandria Commission for Women for her work as an advocate on housing issues.

Eudora was born in Alexandria on January 25, 1918, to George Thomas Lee Sr. and Eliza Goffney Lee. She was married to Perry Hamilton Lyles Jr. The couple had four children: Perry and Johnathan L. Lyles, Eudora Forrest and Paula Price. She was a member of Meade Memorial Episcopal Church. Mrs. Lyles died in Alexandria on July 6, 2000.

A. MELVIN MILLER

November 14, 1931–

Melvin Miller is best known to many Alexandrians for his long service on the board of the Alexandria Redevelopment and Housing Authority (ARHA), but for over fifty years, he has made other contributions that have improved the city of Alexandria and uplifted the people who live there.

After graduating from Howard University Law School in 1955, Miller served two years in the United States Army. He married Eula Blanche Malette of Maxton, North Carolina, in Alexandria in 1957, and the couple moved to Alexandria in 1958. He opened his first law office at the corner of Alfred and Queen Streets, where he began his practice as a criminal lawyer. Soon, he began offering pro bono services to civil rights activists, helping many involved in school desegregation cases and lunch counter sit-ins throughout the 1960s.

Miller explained his long interest in affordable housing when he and his wife, Eula, were named Living Legends of Alexandria in 2008: "I've always felt that in this city, with all the good intentions people have—when it comes down to housing the poor, it's too easy to do nothing."

When the Millers arrived in the city, they had trouble finding a place to live, first renting a room in a teacher's home. "You couldn't rent an apartment outside the African American community," Mr. Miller said. "Most teachers, lawyers and doctors who served this community lived outside the city limits in Fairfax or D.C. and commuted." Miller pursued equality and justice in all areas affecting the civil rights of individuals, but over the years, he focused increasingly on housing issues, both professionally and in his civic and volunteer work.

Miller was born November 14, 1931, in Savannah, Georgia, but grew up in Haddonfield, New Jersey, where he graduated from high school at sixteen. He later graduated from St. Augustine's College in Raleigh, North Carolina. "It was the first place where people made me think I could do something meaningful," he said. He has since encouraged many young Alexandrians to study at the college, where he has served on the board of trustees.

Miller was appointed deputy under secretary at the United States Department of Housing and Urban Development (HUD) during the Carter administration. He retired from HUD in 1997. Miller was a member of the Alexandria School Board from 1986 to 1993, serving as chairman from

A. Melvin Miller, attorney and civil rights activist. © *Living Legends of Alexandria/Photo by Nina Tisara.*

1990 to 1992. He served on the ARHA board from 1970 to 1977, chairing it from 1971 to 1977 and again from 2001 to 2012. A past chairman of the Departmental Progressive Club Board, he was elected president of the club in 2012.

Miller and his wife, Eula, had three children: Eric (deceased), Marc and Ericka. Eula, who was a leader in promoting early childhood education in the city, was program head of Early Childhood Education at Northern Virginia Community College. She died on January 5, 2011.

HELEN ANDERSON MILLER

December 22, 1916–December 19, 2005

Helen Miller was a civic activist and leader on many fronts in Alexandria. She was one of the first forty-five members of the Alexandria Economic Opportunities Commission, where she helped organize a daycare center. She was a member of the city task force to build a new detention center, as well as a member of the Boys and Girls Club, the Mothers Club, the Martin Luther King Memorial Commission, the Black Heritage Committee, the Parker-Gray Alumni Commission and the Urban League Forum. She was one of the original members of the Inner City Civic Association, in which she was very active. She and Bernard Hunter were the first African Americans in the city to have a park named after them.

Mrs. Miller chaired the Police Department Community Action Team and was in the first class to graduate from the Citizen Police Academy of Alexandria. In 1946, she joined the Parker-Gray PTA, where she served as president and school representative for the Red Cross. She was a member of the Juvenile Justice Commission, the United Way and the YWCA Board, as well as chair of the Y-Teens program. She was a member of the Alexandria Democratic Committee and the Housing Hygiene Board. She served on the fundraising board to build the new Alexandria Hospital and was a founding member of the Hopkins House Neighborhood Federal Credit Union, where she served as secretary for five years.

For more than fifty years, Helen Miller was a dedicated member of the Ebenezer Baptist Church, where she chaired the Civic and Social Action Committee for over twenty years and became a member of the Powers Committee (dealing with employment issues), the Hand and Hand Club, the Max Robinson Aids Commission and the citizen group for seniors.

Mrs. Miller was recognized for her service to the community with many awards, including those from the Hopkins House Association (1980), the Alexandria Police Department (under Chief Stroble in 1980), the Alexandria Commission on Women (1987), the Departmental Progressive Club (1987), the Alexandria Boys Club (1990), the Loraine Atkins Award (1992) and the Eastern American Indians (1990). In 1991, Ebenezer Baptist Church recognized her for forty-nine dedicated years of service. In 2007, Hopkins House named one of its annual awards the Helen Miller Community Award, in her honor.

Helen Anderson Miller (second from right), civic activist and community leader, at an NAACP award ceremony. *Alexandria Library, Special Collections, Alexandria, Virginia.*

Mrs. Miller was a native Alexandrian and was educated at the original Parker-Gray School. She was the wife of the late Charles E. Miller of Alexandria, and they were the proud parents of six children—five daughters and one son. She was a grandmother, a great-grandmother and a good friend to many people in the community.

ARTHUR NELSON

November 9, 1927–

Arthur Martin Nelson was one of the early African American letter carriers in Alexandria, Virginia. He held the position of mail carrier for thirty-eight years and knew most of his customers by name. Active in his community, he became vice-president of the Departmental Progressive Club, responsible for the organizational management of the club. He has been a member of Elks

Arthur Nelson, one of the first African American letter carriers in Alexandria, Virginia. *Photo courtesy of Arthur Nelson, Alexandria, Virginia.*

Lodge No. 48 for more than fifty years and a member and trustee of Beulah Baptist Church since 1948. He was instrumental in many civil rights programs during the segregation period.

Mr. Nelson was born on November 9, 1927, in Alexandria. Nelson's parents were from Fredericksburg, Virginia. Arthur was the youngest of eleven children. His father, Linwood Nelson, was a waiter on a steamboat in Fredericksburg before the family moved to Alexandria sometime after 1910. In Alexandria, Arthur's parents, Linwood and Carrie, rented a house at 278 Duke Street, and Linwood worked at the shipyard. Documents show that by 1920, Arthur's parents had eight children. By 1930, Linwood and Carrie had eleven children, including young Arthur, and they were living at 224 West Street.

Arthur spent his elementary school years at Lyles-Crouch Elementary School and attended Parker-Gray High School for two to three years before dropping out. He enlisted and served a short time in the military but was discharged when it was discovered that he was underage. Arthur worked as a mail carrier for thirty-eight years, though he was not the first African American to hold the job of mail carrier. Rosier Thompson, another African American mail carrier, began delivering mail as early as 1920. Many African Americans in Alexandria knew Arthur Nelson as their mailman and as a community leader.

MARY E. RANDOLPH

November 6, 1913–February 13, 1989

Mary E. Randolph was a cafeteria worker who saved and invested her earnings to leave to close friends and to benefit the African American community of Alexandria. She was typical of so many ordinary people who rose above circumstances to do extraordinary things in a quiet way.

Ms. Randolph was a cafeteria manager at Parker-Gray High School and manager of other cafeterias in the public school system in Alexandria before she retired. She was also a church pianist for several choirs at Mt. Jezreel Baptist Church. In 1988, after learning of her terminal illness, she prepared her will. In that document, she wrote, "In my life, I have tried to be of service to the community and to my church, and other churches, and try to help others, according to their needs." Ms. Randolph left monies to individuals who influenced her life and the Alexandria African American community. She gave a total of $6,100 to seven ministers to assist them in their ministry; a total of $50,000 to six of her closest friends; a total of $30,000 to two churches; $2,000 to the Hopkins House Association's senior citizen group, the Crunch Bunch; $43,000 to the Hopkins House Association; $23,000 to the Alexandria Boys Club; and other monies to her family members.

Ms. Randolph loved to play the piano for the choirs at her church. The money she left to the Hopkins House came with instructions that the funds should be used to teach music to the children. She directed that all her assets be liquidated, leaving an estate of over $300,000 to be used to pay off her bills and to distribute to the community that she so much loved.

Mary E. Randolph was born November 6, 1913, in Alexandria to Chauncey Randolph and Kate Haley. Never married, she lived at 402 North Fayette Street. At the time of her death, she was seventy-five years old. She had one sister, Agnes Randolph, and one niece, Denese E. Randolph.

Ms. Randolph's will demonstrated a belief that one comes into this world with nothing and will leave it with nothing. She was a hardworking woman who gave all she had to her community and the people she loved.

Katie Nelson Skinner

January 28, 1908–September 30, 1986

Katie Nelson Skinner was instrumental in forming the first African American Red Cross volunteers, known as "The Gray Ladies," at the Alexandria Hospital. She was a long-term member of the American Red Cross Board of Directors, which recognized her long volunteer service to the organization with an award in 1982. She was also a member of the Bethune Branch of the Young Women's Christian Association (YWCA), the Board of Directors of the League of Woman Voters and the American Cancer Society.

Katie Nelson was born in 1908 to Linwood and Carrie Noel Nelson in Fredericksburg, Virginia. They relocated to Alexandria when she was quite young, and she attended public schools here. She met and married Dr. William H. Skinner, Alexandria's first black pharmacist. They resided for many years at 614 South St. Asaph Street, where they loved to entertain. She was widely known for her culinary skills and was the secretary of the Needlework Guild, which made garments for distribution to the needy.

A longtime member of the Roberts Memorial United Methodist Church of Alexandria, Mrs. Skinner served there in various capacities for many years. She was always willing to help, especially when it came to decorating for special occasions. She is recognized at the Alexandria African American Heritage Park.

Mrs. Skinner died on September 30, 1986, at Fairfax Hospital. Preceded in death by her husband in 1982, she was survived by seven brothers—Bernard Nelson of Cumberland, Virginia; Isaac Nelson of Chapel Oaks, Maryland; and Lynwood, Frederick, Arthur, Charles and William Nelson, all of Alexandria— as well as four sisters: Celestine Hill of Richmond, Frances Gray of Chapel Oaks and Edna Taylor and Doris Collins, both of Alexandria.

John A. Stanton

November 13, 1913–September 13, 1999

John A. Stanton was an active participant in the civic life of Alexandria. He was a founding member of the Olympic Boys Club, an African American

organization. During desegregation, the Alexandria Boys Club and the Olympic Boys Club merged to become the Alexandria Olympic Boys and Girls Club, of which he was a board member. He served on the boards of directors of Alexandria Hospital, the Hopkins House, the Alexandria Office on Aging, the Potomac Yards Revitalization Committee, the Mental Health Association of Virginia and the Alexandria Red Cross. He was a community liaison to the Alexandria Mental Health Association, a Mason, an Honorary Member of the Alexandria City Council and a member of Elks Lodge No. 48.

John Stanton received many honors for his community activism, including the American Red Cross Burke Award, which he received jointly with his wife Marian, and the George Washington Leadership Medal from the Alexandria Chamber of Commerce.

He was born in Leesburg, Virginia, where he lived with his mother, but moved to Alexandria at age fifteen to live with his brother, the Reverend N. Howard Stanton, then pastor of Ebenezer Baptist Church. After graduating from Dunbar High School in the District of Columbia, he served in the United States Army, becoming a quartermaster. After military service, he worked as a civilian with the United States Department of the Navy for thirty years before retiring.

John married Marion E. Jackson of Alexandria. Married for more than fifty years, the couple had two children—John Jr. and Carole. A member of Ebenezer Baptist church for more than fifty years, he loved his family and the Lord. John was also an entertaining conversationalist and an avid reader. His grandson, Harold S. Miner, said his grandfather's favorite quote was, "Where there is no vision, people perish." John Stanton died in Alexandria in 1999 and is buried in Quantico National Cemetery.

The vision of John A. Stanton Sr., like that of many other civic leaders of his era, reached well beyond his lifetime. He is remembered for his legacy of work, determination and love for people.

ROBERT ISAAC TERRELL

July 14, 1892–April 20, 1972

Robert Isaac Terrell, born in Alexandria in 1892, played an important role in the civil rights history of the city's African American community, helping

to guide the transition from segregation to desegregation. He was the fourth official president of the Alexandria Chapter of the National Association for the Advancement of Colored People (NAACP). He led the Alexandria Chapter of the NAACP in the turbulent years of the civil rights movement. The exact dates of his presidency are missing in the records, but newspaper reports list him as president as early as 1954, and he is believed to have served until 1969.

As president of the NAACP, he was recognized as a leader of the Alexandria African American community. In 1960, Mayor Bendheim of Alexandria set up a biracial committee of twenty people to look into a "quiet and unobtrusive desegregation" of Alexandria's merchants. Mr. Terrell was one of the four African American leaders selected for that group. In 1961, when racial demonstrations became common, Mayor Frank E. Mann called on Robert Terrell to deal with Alexandria's racial issues. Also in 1961, Mr. Terrell asked Commonwealth Attorney Earl F. Wagner to investigate the killing of an African American man by an Alexandria policeman. In 1963, Terrell organized about two hundred Alexandria African Americans to attend the March on Washington. He also organized a 1964 voter registration campaign, registering three thousand African American voters. In 1966, Mayor Mann selected Mr. Terrell to serve on a committee as part of the War on Poverty.

Prior to becoming active in the NAACP, Mr. Terrell was an executive organizer of community activities in Alexandria as early as 1915. He was an active member and a past exalted ruler of Council 25 of Alexandria Elks Lodge No. 48. In 1932, he was a member of the Roosevelt-Garner Club, which was composed of African American voters who urged other African Americans to vote.

In his professional life, Mr. Terrell was an agent for the Richmond Beneficial Insurance Company and also owned a real estate business at 418 North Patrick Street in Alexandria. When African Americans had difficulty in getting bank loans, Mr. Terrell often gave them a loan.

Robert Isaac Terrell was born in Alexandria on July 14, 1892, to Thomas Jr. and Elizabeth McIntosh Terrell. He died April 20, 1972, at his residence at 1107 Queen Street. He was survived by his wife, Irene; sister, Elizabeth; and several nieces and nephews. His funeral was held at Shiloh Baptist Church.

Ruby J. Tucker

October 11, 1932–September 20, 2009

Ruby J. Tucker devoted much of her life to further justice and equality for the African American population of the city of Alexandria. Her professional career equally exemplifies her devotion to serving others. At the Alive Child Development Center of Alexandria, she worked as a preschool teacher for ten years and as the center director for thirteen years, a career from which she retired in 1995.

Originally hired there as a teacher's aide in the mid-1970s, she went back to school, enrolling in the early childhood education program at Northern Virginia Community College, where she earned an associate degree in applied science at age fifty-seven. She was then promoted to teacher and eventually director. She was instrumental in securing accreditation for the school and became a member of the National Association for the Education of Young Children. She was a founder of the Alexandria Association for the Education of Young Children.

Always active in her neighborhood, Ruby Tucker worked with the Lynhaven Civic Association, Alexandria City staff and the Alexandria Police to combat drug and nuisance activity in the neighborhood where she lived, cleaning up the area "block by block, alley by alley," as one tribute to her stated. She also served on the Lynhaven Flood Victims Relief Program. Her efforts earned her the unofficial title of "Queen of Lynhaven."

Mrs. Tucker (whose maiden name was Belle) made a difference in the lives of youth throughout Alexandria. She volunteered at schools, serving as president and cofounder of the T.C. Williams Athletic Boosters Club and president of the Parent Teacher Associations of Cora Kelly, Parker-Gray High (where she had been a student) and John Adams schools. She volunteered for voter registration for more than a decade and served for twelve years on the Alexandria Housing and Redevelopment Authority, where she was a voice for the city's neediest citizens. She was a member of the Human Relations Task Force to improve race relations in the Alexandria City Public Schools.

Ruby served on the National Council of Christians and Jews' School Community Relations Advisory Committee and on the Alexandria Democratic Committee. She was the chief elections official of the Cora Kelly Precinct. Among her many awards were the Community Builders

Ruby J. Tucker, civic activist and community leader. *Photo courtesy of Patricia Tyler, Alexandria, Virginia.*

Ruby J. Tucker in her role as a deaconess. *Photo courtesy of Patricia Tyler, Alexandria, Virginia.*

Award from Masons of the Commonwealth of Virginia, the 1984 Community Service Award from the Alexandria Boys and Girls Club, the 1995 Appreciation Award for community service from the Northern Virginia Branch of the Washington Urban League and the 1993 Marguerite Payez Leadership Award from the Alexandria Commission on the Status of Women. The Alexandria United Way recognized her with its Outstanding Citizenship Award, and Hopkins House presented her with an award for her years of dedicated service to children in foster care. She also received the NAACP's Community Service Award in 1995, the Alexandria Harmonizers Award and the Whitney M. Young Jr. Award of the Washington Urban League in April 1979 for outstanding community service.

DOROTHY EVANS "PEACHES" TURNER

January 4, 1929–

Mrs. Dorothy Evans Turner is a pioneer in advocating for the rights of poor citizens in Alexandria. She was instrumental in giving public housing residents a voice to air their concerns to public officials concerning their conditions.

Mrs. Turner became a strong activist after moving into Alexandria's John Roberts public housing development in 1968, finding the conditions there less than adequate. Many of the people who lived in public housing felt intimidated and disrespected by the Alexandria Redevelopment and Housing Authority (ARHA).

Working with Gwen Menefee-Smith, Mrs. Turner spent many years educating officials and the public and fighting for better conditions for the poor and minorities in Alexandria. The women worked with the Urban League, the NAACP, local attorneys and other advocacy organizations to improve housing conditions. They founded the Alexandria Tenants Council in 1970. Their initial goals were to work with the City of Alexandria

and ARHA to eliminate discriminatory and unfair regulations of housing policies, but they found that there were other issues to be addressed as well, including legal, economic, social and educational support for tenants. They fought to preserve and increase the stock of public housing in Alexandria.

Dorothy Evans "Peaches" Turner, community leader and activist. © *Living Legends of Alexandria*/Photo by *Nina Tisara.*

In addition to improving public housing, Mrs. Turner pushed for African American representation on the city council and on the ARHA board. She and Mrs. Menefee-Smith worked tirelessly to increase the number of registered minority voters. In the 1970s, Mrs. Turner and her friends picketed the Yellow Cab Company and the ABC Liquor Store for not hiring African Americans.

Even today, Mrs. Turner still advocates for minority residents and seniors. Alexandria's Hispanic public housing community has recognized Mrs. Turner by giving her a plaque for her forty years of community service.

Dorothy Evans Turner was born at 805 South Fairfax Street to William and Mary Johnson Evans. Her parents had ten children. She lost her mother at age seven and then lived with her sister at 610 South St. Asaph Street. She attended St. Joseph's Elementary School and Parker-Gray High School. She married Howard Turner on August 12, 1952.

Chapter 4
JUSTICE AND LAW

B eginning with the Declaration of Independence in July 1776, the United States of America has proudly affirmed a tradition of being governed by law.

We hold these truths to be self-evident, that all men are created equal, that they are endowed by their Creator with certain unalienable Rights, that among these are Life, Liberty and the pursuit of Happiness. That to secure these rights, Governments are instituted among Men, deriving their just powers from the consent of the governed.

Those words, beginning the second paragraph of "The Unanimous Declaration of the Thirteen United States of America" back at the beginning of our country, represent noble aspirations. But as it turned out, those truths—particularly that "all men are created equal"—were not always so self-evident to the American populace. Native Americans were not equal, African American slaves were certainly not equal and until far too recently, women were not equal.

By the twentieth century, despite having been emancipated from slavery, African Americans were still struggling to have anything approaching equality. Educated members of the African American community recognized that achieving equality would take a struggle, and one of the most critical steps in gaining their civil rights under the constitution was having their equality established as a matter of law. One cannot force a just view on the human heart, but one can enforce justice and equality under the law.

The earliest African American attorneys often walked a difficult path to achieving their credentials. Practicing in courts dominated by white lawyers, judges and juries was likewise not easy. Financial stability was hard to achieve when many clients were impoverished. Yet men of conscience (and in that time it was men—even white female lawyers were still rare if not unheard of) fought to become lawyers and to advance the cause of equality before the law for their people. They fought for equality and the opportunity to work at any job for which the worker was qualified. They fought for equal access to integrated schools and hospitals and for the right to teach and practice medicine in those facilities. They fought for the right to eat in the same public restaurants, travel on public transportation in the same spaces and seats, use the same public restrooms, drink from the same water fountains and shop in the same stores.

Here in Alexandria, as elsewhere, the practice of law was a risky career choice for African Americans, financially as well as in other ways. Samuel A. Tucker, who is written about in our chapter on business entrepreneurs, was trained as a lawyer but made his living in real estate. His office partner, Thomas Watson, did practice as an attorney, successfully defending, among others, Samuel's young son Samuel Wilbert Tucker and his brother when they were arrested for riding in the "whites only" section of a streetcar. Melvin Miller, who is recognized in this volume's chapter on civic and community leaders, earned a law degree from Howard University and made his early career the practice of criminal law in Alexandria, including years of pro bono work on civil rights cases involving schools and lunch counter sit-ins before moving on to a career in the federal government promoting affordable housing.

Watson was a powerful influence on young Samuel Wilbert Tucker, mentoring him in the reading of law books from a young age. S.W. did legal research for Watson and eventually became a powerful civil rights attorney in his own right, serving as one of the leading lawyers with the Virginia branch of the NAACP.

James H. Raby, who began practicing in Alexandria in 1941, led the way in cases desegregating transportation and defending the rights of the disabled.

The early career of Joseph C. Waddy exemplified the difficulty of making a living in the legal profession. When he first practiced law with the firm of the distinguished civil rights advocate Charles Hamilton Houston in the District of Columbia, Waddy worked without salary, supporting himself with the forty dollars a month he earned as an elevator operator. Eventually, he told Mr. Houston he needed to support a family, and Houston began

paying him. Mr. Waddy won numerous cases over the course of his career and rose to become a federal judge, appointed by President Lyndon Johnson in 1967.

Being an African American lawyer in the mid-twentieth century often meant being willing to put yourself at risk, to lead boldly even when threatened, to defend seemingly hopeless cases, to chip away at the habits and customs so long entrenched in the surrounding society. By dogged persistence and hard-earned knowledge of detail and precedent, these civil rights lawyers slowly changed the laws and legal procedures organizing our government to be more equitable for all people. Our society is still imperfect, but we owe those pioneer African American attorneys a great deal. Their success is measured in many ways, not the least of which is that Alexandria's present city attorney is an African American.

JAMES H. RABY

December 25, 1896–September 3, 1981

James H. Raby was an attorney who established a private law practice in Alexandria, Virginia, in 1941. He and his firm, Raby & Stafford, handled many cases defending African Americans during the segregation era, including helping to win a case that desegregated bus travel in Virginia. He also defended mentally incapacitated people who were being treated as criminals. He was a member of the bar in the District of Columbia and Virginia.

Mr. Raby maintained residences in Alexandria and Washington, D.C. He was a member of the Campbell African Methodist Episcopal (AME) Church in Washington, where he served as chairman of the board of trustees, teacher and assistant superintendent of the Sunday school and a member of the Men's Club. He was president of the Lay League of the Second Episcopal District of the AME Church, national legal counsel to the Lay Organization of the World and a member of the Elks, the Prince Hall Masons and the Pigskin Club. In 1944, *The Washington Post* listed him as chairman of the Negro division in a wartime Red Cross Drive.

Born in Norfolk on December 25, 1896, Raby graduated from Armstrong High School in Washington, D.C. He earned his law degree at Howard University, working his way through school with jobs at the post office,

the Government Printing Office and elsewhere. He died of a pulmonary embolism at Howard University Hospital on September 3, 1981, at the age of eighty-four. His wife, Georgia F. Raby, died in 1966. He was survived by three daughters, Frances R. Richardson of Hampton, Mildred L. Raby of Washington and Mary Stafford of Arlington; a twin brother, Walter John Raby of Philadelphia; and five grandchildren.

Samuel W. Tucker

June 18, 1913–October 19, 1990

Samuel Wilbert Tucker was among the first African Americans in Alexandria to confront city officials on the issue of Jim Crow laws that denied equal rights, civil rights and human rights to its citizens despite the United States Constitution.

In 1939, Tucker, then a twenty-six-year-old lawyer, forced Alexandria to open Robert H. Robinson Library for African Americans, although his goal was to gain use of the whites-only Alexandria Library. Tucker had recruited six young African American men to participate in a "sit-down strike" in the Alexandria Library on Queen Street to demand their rights to access. When the men were denied library cards and arrested, he filed suit on their behalf. The court ruled against the young men on a technicality, not because there was any city regulation limiting the library to whites. Though many hailed the city's decision to open a library for blacks, Tucker was disgusted, as what he wanted was equal access to all facilities, not a separate, lesser library for blacks.

Tucker was born at 918 Queen Street in Alexandria on June 18, 1913. His father was Samuel A. Tucker, a real estate agent who shared office space with Thomas Watson, a lawyer who became Samuel Wilbert's mentor. S.W.'s mother, Fanny, was a former schoolteacher. He graduated from Parker-Gray School before it became a high school. In those days, black students had to travel to other cities to attend high school. He traveled to the District of Columbia by streetcar to attend Armstrong High School, graduating at age sixteen.

When Tucker was fourteen, he had one of several formative encounters with injustice while riding on a streetcar in Washington. His little brother, Otto, flipped a reversible seat so that he and S.W. could face their brother George and his friend. Once the car crossed into Virginia, a white

Civil rights lawyer Samuel
W. Tucker with a group of
children. *Photo courtesy of
Ferdinand T. Day and Gwen Day
Fuller, Alexandria, Virginia.*

woman ordered Otto to move because his seat protruded into the "whites
only" section of the car. Otto ignored her. When the trolley arrived in
Alexandria and the Tuckers got off, the woman followed and had them
arrested. The two older boys were taken to court. They were fined in
police court, but a neighbor found lawyer Watson, who appealed the
case. An all-white jury found the boys innocent. The case made a huge
impression on S.W. and became a further encouragement to become an
attorney like Mr. Watson.

After graduation from Armstrong, Tucker continued his studies at
Howard University, where he met law professor Charles Houston, who
led the fight against segregation for the NAACP. Tucker graduated from
Howard University at age twenty and passed the bar exam in 1933 without
attending law school. (He had been reading Watson's law books since the age

of ten and later researched cases for him at the Library of Congress.) He was admitted to the Virginia State Bar in 1934 at age twenty-one.

During World War II, Tucker served in the all-black 366th Infantry Division, rising to the rank of major. After the war, he resumed his legal practice, moving his office to Emporia, Virginia. After the United States Supreme Court ruled against the separate-but-equal doctrine in *Brown v. Board of Education* in 1954, Virginia reacted with a policy known as Massive Resistance. Tucker became one of the leading civil rights lawyers with the Virginia branch of the NAACP. During the 1960s, Tucker took the lead in litigating many cases dealing with school desegregation in Virginia, including in Charlottesville, Lynchburg, Prince Edward County, Powhatan County and King William County. These were groundbreaking cases that laid the foundation for civil rights cases dealing with equal rights in employment and public accommodations under the Fourteenth Amendment.

During the 1960s, S.W., as he was known, joined Oliver W. Hill and Henry L. Marsh III to form the law firm Hill, Tucker & Marsh in Richmond. His partner Henry Marsh once said of Tucker and his civil rights work, "He was the brains behind the movement." Yet Tucker was a quiet man whose actions were not widely known until well after his death. The Virginia Bar Association tried to disbar him on false charges in 1960 but failed.

In 1947, Tucker married Julia E. Spaulding. The Tuckers had no children. S.W. Tucker died October 19, 1990, in Richmond, Virginia. He is buried at Arlington National Cemetery, where he shares a grave with his younger brother Otto, with whom he committed his first civil rights act of quietly refusing to give up a seat on a streetcar when Otto was ten and he fourteen.

In 1999, the Alexandria School Board voted to name its first new school building in thirty years the S.W. Tucker School. The former Robinson Library is now the Alexandria Black History Resource Center.

JOSEPH C. WADDY

May 26, 1911–August 1, 1978

Joseph C. Waddy distinguished himself throughout his life as a student, lawyer and judge and rose to become a United States district court judge.

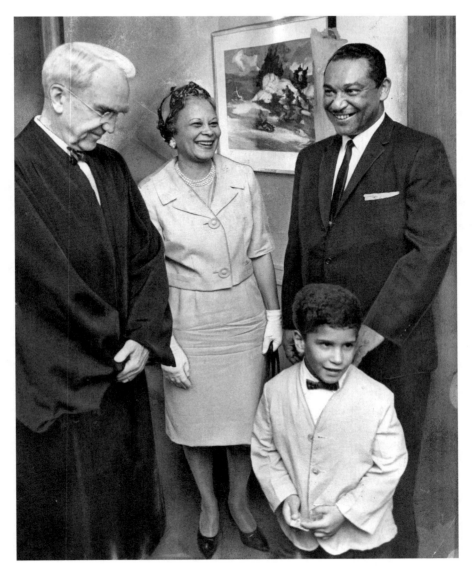

Judge Joseph Waddy and family and Judge Henry Edgerton of the U.S. Court of Appeals after the ceremony swearing in Judge Waddy as an associate judge on June 19, 1962. *Reprinted with permission of the D.C. Public Library, Star Collection.* © Washington Post.

Born in Louisa County, Virginia, in 1911, Waddy moved to Alexandria with his family in 1918 when he was seven years old. In 1928, as a seventeen-year-old student of Parker-Gray School, he won first prize in the Second

Annual Oratorical Contest conducted by the Board of Education of the Improved Benevolent Protective Order of Elks of the World, headquartered in Chicago. The prize was $500 in cash. The candidates spoke on subjects relating to the constitutional rights of the American Negro.

Later, his family moved to the District of Columbia, where he graduated from Dunbar High School. Waddy graduated with honors from Lincoln University in Pennsylvania in 1935. He won a scholarship to Howard University Law School and graduated at the top of his class in 1938. The following year, he was admitted to the District of Columbia Bar (a local electrician gave Waddy twenty-five dollars to cover the cost of taking the bar exam) and joined the law firm headed by Charles Hamilton Houston. Houston was a tireless civil rights advocate who died in 1950, the same year an elementary school bearing his name was established in Alexandria.

At first, Mr. Waddy worked for Houston's firm free of charge, supporting himself on the forty dollars per month he earned as an elevator operator. Soon, Waddy told Mr. Houston he had to decide whether to be an elevator operator or a lawyer, as he needed to make a living, so Houston began paying him for the legal work he performed. Waddy practiced law until 1962, except for a two-year period from 1944 to 1946 when he served in the U.S. Army. After being honorably discharged as a sergeant, he returned to Washington, D.C., where he became a partner in the law firm of Houston, Waddy, Bryant and Gardner.

Houston and Waddy won a number of the major cases in that era, particularly cases involving discrimination in labor and violations of the Fourteenth Amendment to the United States Constitution. They won cases striking down discrimination against railroad workers, teachers, students and a host of underprivileged victims. They won one Baltimore case in which the court ordered a previously all-white golf course to open to all because the City of Baltimore had violated the Fourteenth Amendment by denying colored persons the right to play there.

In 1962, Judge Waddy was appointed to the municipal court for the District of Columbia (now known as the Superior Court) domestic relations branch, a position he held until he was appointed to the federal bench by President Lyndon Johnson in 1967. His years on the federal bench were noted for a series of rulings aimed at improving education in the District's public school system. He continued to be active in the civil rights area.

Despite the prominence of the Houston law offices and the scope and importance of the work, Waddy had earned little money. The prospect of financial stability was a factor in his accepting the appointment to the municipal court, friends recalled.

Judge Waddy was married to the former Elizabeth H. Hardy. They had one son, Joseph C. Waddy Jr. In his later years, Judge Waddy suffered from emphysema and a heart disorder. He retired on July 31, 1978, and died the next day, August 1, 1978, in Washington, D.C.

THOMAS M. WATSON

May 4, 1898–December 1967

Thomas M. Watson was a respected Alexandria attorney and real estate partner with Samuel A. Tucker, the father of the passionate civil rights attorney Samuel W. Tucker. Mr. Watson was the attorney who guided and prepared young Samuel to become a great civil rights lawyer, although S.W. Tucker's lifelong commitment to education and civil rights no doubt germinated from the example set by his parents. Nevertheless, Thomas Watson started young Tucker's legal education before he was a teenager, encouraging him to read legal texts and mentoring his study.

By the time he was fourteen, Tucker had written his first deed. On at least one occasion, he prepared Watson's clients for court. Consequently, it was no surprise to those who knew Watson and Tucker that young Samuel Wilbert Tucker bypassed law school. Six months after graduating from Howard University, Tucker took the Virginia bar exams and passed. Because he was only twenty years old at the time, he had to wait a year until he turned twenty-one to be licensed to practice law. Young Tucker's success was a tribute to both Attorney Watson's skill as a teacher of law and Tucker's brilliance.

Lawyer Watson also provided young Samuel W. Tucker with a prime example of the value of the legal profession, representing Samuel and his brother George in court when they were arrested for allegedly riding in the "whites only" section of a streetcar. Though the boys had been fined in police court, Watson appealed the case, and a jury found the boys innocent.

Watson died on December 31, 1967. At his funeral, held at Roberts Chapel Methodist Episcopal Church in Alexandria, William P. Wools, judge of Alexandria's corporation court, spoke of his years of association with Watson. Several prominent lawyers from Washington,

D.C., were present to honor the deceased. The Alexandria Lodge of Elks and Lancaster Lodge of Odd Fellows held services at the church. The Lincoln Lodge No. 11, A.F. and A.M., conducted services at the grave. The honorary pallbearers were Edward Hill, Benjamin Gaskins, Alfred Collins and Fairfax Jackson.

Chapter 5

MEDICINE

For African Americans, access to medical care has a complicated history. Africans brought to America as slaves were subject to the abysmal conditions of the Middle Passage. Slave traders kept their cargo just healthy enough to make a profit. After being sold into slavery, these men, women and children did not fare much better.

Slaves in an urban environment or on a plantation were at the mercy of their masters for medical care. Most masters, like slave traders, did the minimum to keep their "investment" productive, but not much more. The enslaved often relied on their knowledge of folk remedies and cures from Africa, adapting them to the plants and foods available in this country. The adaptation process was also carried over to food choices and preparation, music and much of American culture.

For free blacks in the eighteenth and nineteenth centuries, medical care was not much better. Those who could afford to pay a doctor had to hope the doctor would treat an African American. Often, their other options were the local apothecary (if the owner would sell to them) or home remedies. Not to be forgotten is the early role of women in African American medicine. Midwives were always a vital source of medical care for a community. They saved the lives of many mothers and children and treated families for other illnesses as well.

During the Civil War, Alexandria saw an influx of enslaved Africans, beginning in 1861, when Alexandria was occupied by Union forces. These slaves escaping from other areas in Virginia were called contrabands. Contrabands

survived in a unique limbo. While behind Union lines, contrabands were free, and their labor was used to support the Union defense.

Living conditions in Alexandria during the Civil War were difficult at best for white and free black citizens, but they were horrible for the contrabands. Forced to live in shanty housing throughout the cities and towns to which they migrated or wherever they could find safe space, they suffered a high mortality rate. Men, women and children who traveled long distances seeking freedom often had little access to food, shelter and sanitary conditions. Many fell ill or were injured and did not survive. The construction in Alexandria of L'Ouverture Hospital for the care of African American Union soldiers and contrabands helped somewhat, but there were always more wounded troops and contrabands requiring care, overwhelming the scarce available supplies and personnel.

Alexandria's Contrabands and Freedmen's Cemetery Memorial, due to be dedicated in 2013, is the burial ground for more than 1,800 men, women and children who sought refuge in Alexandria. This site bears witness to the tragic loss of life associated with the Civil War. More than 800 of the burials in the cemetery were of children under the age of five. The horrendous losses of the period served to strengthen the resolve of many African Americans— one day they would be free, and their families would survive.

In 1892, the first African American doctor to practice in the city of Alexandria was Dr. Albert Johnson (1866–1949). He attended Howard University Medical School, the first medical school for African Americans in the United States. Dr. Johnson was a native of Alexandria who lived at 814 Duke Street, where his home still stands today. Albert Johnson was an excellent role model for the generation of doctors to follow.

The six physicians recognized in this chapter had several things in common. Their biggest similarity was their dedication to the practice of medicine and a willingness to go the extra mile for their patients. Each studied medicine at a historically black college or university (HBCU)— three attended Meharry Medical College in Nashville, Tennessee, and three attended Howard University in the District of Columbia. All had a strong sense of public service. Finally, each man, whether he was born in Alexandria or a transplant to the area, left our city a better place through his treatment of patients.

Being a physician is a difficult career path at the best of times, but to aspire to the medical profession during the years of Jim Crow laws was a daunting endeavor. All of the doctors in this chapter received their education under a segregated system and at great costs, both personal and financial.

Even practicing their medicine could, at times, be a challenge. One Alexandria doctor treated emergency cases in his home when the risk was too great to transport the patients. Alexandria Hospital had a separate ward for African American patients, but these patients were seen by white physicians only, as African American physicians were not allowed to practice there during the time of segregation. When a new Alexandria Hospital was constructed in the period from 1912 to 1916, the city's first African American physician, the aforementioned Dr. Johnson, was selected chairman of the committee to raise funds for a men's ward at the new hospital. His committee exceeded its assigned goal of $300, raising $500 for the new ward. Johnson's fundraising for the new hospital was particularly significant. If black patients were admitted at all to hospitals in the South, they were relegated to all-black wards, usually with substandard conditions. Efforts by African American physicians to improve conditions gradually paid off, and health care for African Americans improved dramatically over the course of the twentieth century.

Still, until hospital integration was complete, for Alexandria's pregnant African American women, the choice was often difficult. Those with private physicians had the option to travel to Freedmen's Hospital or Providence Hospital in the District of Columbia or other area hospitals that permitted African American physicians to practice. Many nervous husbands and their pregnant wives opted to drive into Washington rather than be seen at the Alexandria Hospital. Other families relied on the Alexandria Hospital and hoped the doctor chosen would treat them with respect. During segregation, there were stories of pregnant African American women in labor who were denied care from Washington hospitals that did not admit black patients. These horror stories influenced the choices of families hoping to avoid a similar fate.

Alexandria physicians were not always paid, but they served regardless. Often, patients paid what they could—or they paid in other ways. One family remembers their father being paid with a chicken for medical care provided. Another family gratefully remembers their family physician, who would stop what he was doing when called and come to support a young father dying from cancer. The doctor provided the dying man and his family comfort and care that eased their remaining time together.

The men profiled in this chapter, in addition to being doctors, were husbands, fathers and pillars of the community. Dr. James Henry Carpenter spent more than twenty-five years practicing medicine in Alexandria. Dr. Henry Milton Ladrey is remembered by the high-rise

senior citizen apartment complex named in his honor. Dr. Herbert Garland Chissell was a founding member of the Alexandria Chapter of the NAACP. Dr. Aubrey Constantine Lindo, a native of Jamaica who stayed here after receiving his medical degree, was a member of several Alexandria service organizations.

Dr. Oswald Durant had to fight the justice system and a possible life sentence, successfully proving that he was wrongly convicted of assaulting a white woman in the 1920s South. Dr. Charles West was the first African American to play in the Rose Bowl and was almost lynched for it. In addition, Dr. West, who performed tuberculosis research, is believed to be the first physician, white or black, to operate an X-ray machine in his private practice.

Alexandria's African American citizens have fond memories of their physicians. These doctors were by their side at birth and death, when their children were sick, when students received sports injuries and through treatments for cancer and other diseases. They left a legacy of quality care and great compassion still remembered today.

James H. Carpenter, MD

March 1, 1916–September 25, 1985

Dr. James Henry Carpenter was a physician who practiced in Alexandria for forty-two years. In addition to his private practice, Dr. Carpenter was also a clinical instructor in pediatrics at Howard University Medical School.

James H. Carpenter was born in Washington, D.C., the son of James W. and Arrah R. Carpenter. He attended District of Columbia Public Schools and graduated from Dunbar High School and Howard University. He received his medical degree from Meharry Medical College in Nashville, Tennessee, in 1941 and was then commissioned into the United States Army Medical Corps as a first lieutenant. He was an intern at Provident Hospital in Chicago, the first black-owned and operated hospital in the United States when it opened in 1891.

In 1943, Dr. Carpenter began his medical practice in Alexandria. He lived in the District of Columbia with his wife, the former Emette L. Harris, whom he married in Memphis, Tennessee, on June 28, 1942, and their three

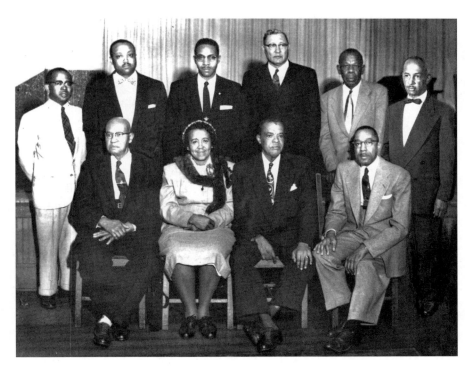

Dr. James Henry Carpenter (front row, second from right) of the Shiloh Baptist Church. *Photo courtesy of Judy Williams of Shiloh Baptist Church, Washington, D.C.*

children. He was a member of Shiloh Baptist Church in Washington, where he served on the church's board of trustees. Dr. Carpenter also was an active member of the Alexandria Medical Society; the Medico Chirurgical Society of Washington, D.C.; the National Medical Association; the First Medical Reading Club; the Hellians; the Bachelor Benedict Club; and the Kappa Alpha Psi Fraternity.

Dr. Carpenter died of cardiopulmonary arrest at Washington Hospital Center on September 25, 1985. He was survived by his wife, Emette; his children, James H. Jr., Barry L., Brenda M. and Karen B.; a sister, Helen A.; and three grandsons, James III, Kevin and Barry.

HERBERT GARLAND CHISSELL, MD
June 25, 1899–November 18, 1957

Dr. Herbert G. Chissell was a prominent physician and surgeon and an active citizen in the Alexandria African American community for more than twenty years. He and his wife founded a family that today has seven doctors in four generations, reflecting the family tradition of achievement and community service.

Dr. Chissell arrived in Alexandria in 1930 and set up his medical practice at 303 North Alfred Street. By 1934, Dr. Chissell had moved both his office and his family residence to 521 South Royal Street, where he lived and worked for about eight years until he completed building a home with space for his medical practice at 417 North Fayette Street. Even today, some older Alexandria African Americans remember Dr. Chissell as a kind and thoughtful doctor.

In addition to his medical practice, in 1933, Dr. Chissell was a founding member of the Alexandria Chapter of the NAACP and became its vice-president. He supported his wife, Connie B. Chissell, in her community work, particularly in her position as a founding member and director of the nonprofit social services agency Hopkins House, and donated money for a Hopkins House building. He was a member of Alexandria's Elks Lodge No. 48.

Dr. Chissell was born in Petersburg, Virginia, on June 25, 1899, to John T. and Flora Chissell. He graduated in 1920 with a bachelor's degree from Livingstone College. While at school, he pledged with the Omega Psi Phi Fraternity. He married Connie Belle Sitgraves in Tennessee in 1921. After earning his MD from Meharry Medical College in 1924, he set up a private medical practice in Charlottesville. In 1930, he moved from Charlottesville to Alexandria, and in 1931, his wife and three children joined him.

In the early 1950s, Dr. Chissell suffered a stroke at his home on Fayette Street. The stroke ended Dr. Chissell's twenty-two-year medical career in Alexandria. His wife, Connie, left her position as director of the Hopkins House, and the couple moved to Baltimore to be near their two sons, both of whom were physicians practicing in that city. Dr. Chissell died in Baltimore in November 1957 of complications from the stroke. He was survived by his wife and three children, Herbert G. Chissell Jr., John T. Chissell and Connie Chissell Young.

Oswald Davidson Durant, MD

September 5, 1895–April 10, 1953

Dr. Oswald Davidson Durant was one of the few African American physicians in Alexandria in the period from 1927 to 1953. He was a member of the Medico-Chirurgical Society of Washington, D.C., a local medical society affiliated with the National Medical Association that was formed to aid physicians of color who were barred by many whites-only medical associations. For many years, Dr. Durant could not practice at Alexandria Hospital because of segregation. Often, patients of color in need of emergency care would go to his home in the middle of the night to be treated for their injuries.

Dr. Durant was an active community leader and devoted significant time to public health campaigns. He served as chairman of the Negro Division of the Community Chest Drive in 1952, receiving an award for fundraising efforts. He was a member of the Alexandria branch of the NAACP, a board member of the Hopkins House Association, first vice-president of the

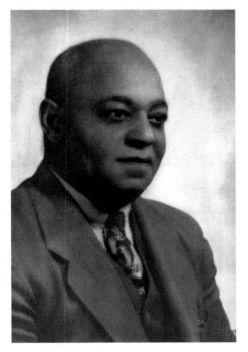

Alexandria Citizens' Association and a member of the advisory committee of the Pendleton Street Recreation Center. In the 1940s, he was very active with the Alexandria Committee for Interracial Cooperation.

Dr. Oswald Davidson Durant, physician and community leader. *Photo courtesy of Dr. Nancy A. Durant, Plainfield, New Jersey.*

Oswald Durant was born on September 5, 1895, in Clarendon County, South Carolina, and later moved to nearby Sumter with his family. In 1917, Durant was drafted to serve in World War I and assigned to the 371st Infantry in the still-segregated U.S. Army. The 371st had white officers and African American draftees, nearly all of whom were from South Carolina. By the time they sailed for Europe in April 1918, Durant had been promoted to the rank of sergeant.

As part of the 93rd Division, the 371st was to assist French regiments but instead was actually put under French command. Sergeant Durant and nearly three thousand other members of the 371st were issued French rations and equipment, including the distinctive French combat helmet. During their service with the French 157th Division, the African American draftees earned the respect of the French military as well as that of many white U.S. officers. The regiment saw extensive combat and lost a third of its men but was honored by the French with the Croix de Guerre before returning home in 1919.

A veteran and a student, Durant worked as a waiter, mail courier and Pullman porter to help pay for his education and to support his mother. In 1920, he enrolled at Meharry Medical College in Nashville, where he became an honor student. Only months from graduation in 1924, Oswald Durant was wrongfully accused of assaulting a white teenage girl. He was arrested, convicted and sentenced to life in prison. An attorney hired by the Nashville branch of the NAACP appealed to the state supreme court, and the conviction was overturned. Durant was set free after a year behind bars, and the charges were never pursued. He graduated from Meharry in 1926.

In 1927, Dr. Durant married Helen Jackson, a teacher from Charlottesville, and they moved to Alexandria. He set up his new practice and young family at 708 Pendleton Street. Dr. Durant, his wife and children, Nancy and Oswald Jr., attended church at Meade Episcopal Memorial Chapel at Princess and North Alfred Streets. Dr. Durant later worshipped at Alfred Street Baptist Church.

Dr. Durant died at age fifty-seven on April 10, 1953, at his Pendleton Street home. He is buried at Arlington National Cemetery.

In 2004, the Dr. Oswald Durant Memorial Center in Alexandria was reopened after extensive renovation. Once the site of a USO center, it is now home to stages and studios for the visual and performing arts.

HENRY MILTON LADREY, MD

c. 1897–August 29, 1982

Dr. Henry Milton Ladrey practiced medicine in Alexandria (where he had an office on Henry Street), Leesburg, Falls Church and Washington, D.C., for forty-five years while also serving in numerous community organizations. In addition to his regular practice, he also provided free medical care to Parker-Gray High School athletes. The Ladrey High-Rise Senior Citizens Apartment Complex in the city is named in his honor.

In 1956, Dr. Ladrey was appointed director of the Shriners Medical Foundation. He was honored with a certificate of appreciation from the Daughters of Isis and served as chairman of the Imperial Council's Tuberculosis and Cancer Research Foundation. He was a member of the Alexandria Board of Trade and was a Life Member of the NAACP. In 1974, he was presented with the key to the City of Alexandria by Mayor Charles Beatley.

Dr. Ladrey was born in Lucia, Jamaica, to John and Caroline Ladrey. He served in the British Armed Forces in Egypt, France and Belgium. He received his medical degree upon graduation from the Howard University School of Medicine in 1932.

Dr. Henry Milton Ladrey, physician and community leader. *Photo courtesy of Alexandria Black History Museum.*

Ladrey was a member of Meade Memorial Episcopal Church, where he served as lay reader and as a member of the choir. A 33rd Degree Mason, Dr. Ladrey was a past master of the Lincoln Lodge No. 11 of Free and Accepted Masons; a member of the Order of the Eastern Star, Shadrack Jackson Consistory No. 156l; and past potentate of Magnus Temple No. 3. He was a member of the Departmental Progressive Club and Elks Lodge No. 48.

Dr. Ladrey retired in March 1977 due to ill health. He died on August 29, 1982. At the time of his death, he was survived by his wife, Eva Wilkins Ladrey; a daughter, Estelle Carolyn Ladrey; three sisters-in-law, Mayme Holt, Vernest Wilkins and Rebecca L. Wilkins; and a brother-in-law, Milton A. Wilkins. His widow, Eva, died on February 16, 2013, in Washington, D.C. Her funeral was held on February 25, 2013, at Ebenezer Baptist Church in Alexandria.

Aubrey Constantine Lindo, MD

November 20, 1909–April 20, 1979

Dr. Aubrey C. Lindo was held in high esteem in Alexandria and Washington, D.C., for his dedicated and unselfish service to medicine and to the community at large. Though he lived in Washington, he practiced in Alexandria and participated actively in the city's civic life.

Aubrey Lindo was born on November 20, 1909, in Jamaica to Frank and Alice Rebecca Lindo, one of seven children. He received his early education in a private school in Jamaica and later enrolled at Cornwell College. In 1929, at age twenty, he traveled to the United States and entered Howard University, where he played on the soccer team. He graduated from Howard in 1934 with a BS in science and then went on to earn his MD from the Howard University School of Medicine in 1937. He completed his internship at Freedmen's Hospital, now Howard University Hospital, in 1938, and in 1939, he completed his residency at Trinity Hospital in Detroit, Michigan.

Dr. Lindo was licensed to practice medicine in Virginia and began his private practice in Alexandria. In 1941, he was also licensed in the District of Columbia. In 1940, he married Ellecia Lindsay of New London, Connecticut, a nurse at Howard University Hospital. The couple lived in D.C. and had two daughters, Constance and Michelle.

Lindo served as member and officer of numerous organizations and chaired and worked on many community projects in both Washington and Alexandria. He was a member of the Medico-Chirurgical Society of the District of Columbia, the National Medical Association, the Howard University Medical Alumni Association (treasurer of the D.C. chapter in 1960 and the association itself from 1965 until his death), the MEDCO Society, the American Cancer Society, the Hopkins House Association, the Alexandria Tuberculosis Association, the National Thoracic Society, the NAACP, the Urban League, the Alpha Phi Alpha Fraternity, the Departmental Progressive Club, the Guardsmen and the Elks.

Dr. Lindo died at age seventy on April 20, 1979, in Washington, D.C. He was survived by his wife, Ellecia, (since deceased) and two daughters, Constance Lindo White (Phillip) and Michelle Lindo Chapman (Gregory).

CHARLES FREMONT WEST, MD

January 25, 1899–November 20, 1979

Charles Fremont West was the first African American quarterback to play in the Rose Bowl (January 22, 1922) and was inducted into the Pennsylvania Sports Hall of Fame in 1979. He was offered an opportunity to play professional football but chose to attend medical school and become a physician instead.

West attended Washington & Jefferson College (W&J) in Washington, Pennsylvania, where he excelled in football, track and field and baseball. He was an offensive back for the 1921 Presidents team, on which he was the only black member, that played to a scoreless tie with the University of California in the 1922 Rose Bowl.

West, known to friends as "Pruner," was almost killed playing in the Rose Bowl when a lynch mob met the team bus shouting that they were there "to kill the N-----!" West, a very light-skinned African American, was the first player off the bus. He told the mob, "We did not bring him." Later, during the game, when spectators realized that West was in fact playing, racial slurs where shouted at him. There was even a display in the town pharmacy of a "Sambo-like" figure (with tag reading WEST) being carted away in an ambulance. After the game, West went to the store and asked the owner,

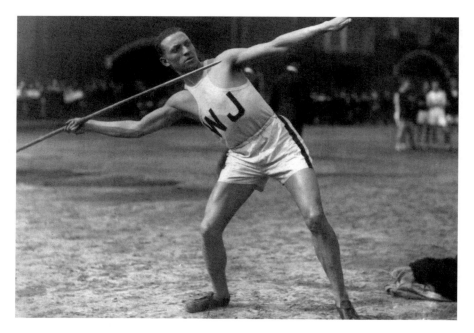

Charles Fremont West throwing a javelin as a college athlete. West played quarterback in the 1922 Rose Bowl and then went on to study medicine and become a physician. *Photo courtesy of Linda West Nickens, Alexandria, Virginia.*

Frank Connors, for the figure. Connors, impressed by his courage, gave the figure to West. It remains in the family collection today.

A little-known but interesting fact about Charles West unites him with John W. Heisman (namesake of the Heisman Trophy), who was W&J's head football coach at the time. During the 1923 football season, the W&J football team was scheduled to play against Washington and Lee University (W&L). When the W&L team, from Lexington, Virginia, found out that an African American was on the W&J team, it said it would not play against the school unless West was benched. In that era, southern colleges and universities were accustomed to having other schools accede to this sort of request. West said that if he were benched, he'd never play again. Heisman declined to bench West. W&L assumed the Pennsylvania team would change its mind and showed up in Pennsylvania to play. When W&J's Heisman didn't knuckle under, W&L said the school would have to pay a $1,000 forfeit. W&J withdrew the money from the bank and paid. Ironically, West had a sprained ankle and could not play. Heisman knew this but still stood by his principles and forfeited the game.

West was chosen to compete in track-and-field events in the 1924 Olympics and went to Paris at the last minute, his travel and participation paid for by Washington and Jefferson College. Once in Paris, he qualified to compete with the team, but French officials refused to permit his participation. On his return from France, West was offered a spot with a professional football team, the Akron Pros, but chose to attend medical school instead. He worked his way through Howard University Medical School by coaching Howard University's football team and in 1934 was made head coach.

West was born to William B. and Hannah Thomas West, a farming family living near Washington, Pennsylvania, and had three siblings: Milton, Dora and Ethel. The family later built a store in Washington where Charles grew up in a house at the corner of North Lincoln and Spruce Streets. The house still stands. Even as a young boy, Charles's athletic prowess engendered stories. It was said he could outrun the family horse and wrestle the family bull to the ground—stories his sister Ethel said were true.

On Halloween evening in 1936, Charles West married LaVerne Gregory in the Gregory home. Miss Gregory was the daughter of the Reverend Professor and Mrs. J. Frances Gregory of Washington, D.C. The wedding was one of the society events of the year in the African American community and was covered in many African American newspapers. At the time of her marriage, Miss Gregory was a Latin teacher at Dunbar High School in Washington, D.C. Previously, she had held a teaching position at Fisk University.

Dr. West practiced general medicine in Alexandria for more than fifty years. The Wests had two children. While living in Alexandria, Dr. West served as the team doctor for Parker-Gray High School. Charles West was also known for his specialized care of tuberculosis patients. His daughter Linda West Nickens remembers that as a result of this care and research, he was the first physician, white or black, to own and operate a private X-ray machine in his office. Charles West retired from the practice of medicine in 1979, shortly before his death at the age of eighty.

Funeral services for Dr. West were held at the Rankin Chapel at Howard University on Saturday, November 24, 1979. His survivors included his wife, LaVerne Gregory West (d. 1987); a son, Charles Nathaniel West; a daughter, Linda West Nickens; and three grandchildren—Crystal E. Nickens, Michael W. Nickens and James B. West.

A Charles Fremont West Memorial Athletic Fund was established at Howard University. Dr. West's grandson Michael W. Nickens is the assistant director of music and director of athletic bands at George Mason University.

In September 2012, Washington and Jefferson College honored Charles "Pruner" West, class of 1924, for his role in advancing the role of African Americans in collegiate sports. In the words of his daughter Linda, who spoke at the ceremony, her father "confronted racial barriers not only in football but also in the medical field."

Chapter 6

MILITARY

T his chapter recognizes some men who had remarkable careers in the military, including General Leo A. Brooks Sr., Lieutenant Colonel Thomas H. Turner and Major Joseph O. Kahoe Jr., but also honors a cluster of lives cut short by service in the Vietnam conflict: Wayne Lamont Jordan, Harry F. Richardson Jr. and Raymond Leroy Williams. These men did not live enough years to create long narratives to leave behind, but they served honorably. Others mentioned in this book as outstanding in other fields served in the military in an interval between education and work life, such as educator and coach Arnold J. Thurmond, who was awarded the French Legion of Honor for his service in France during World War II.

Though most military organizations have a reputation for being bastions of tradition and reverence for the past, the United States military has also been a leader in social change. For many decades of the twentieth century, African Americans were treated as second-class soldiers. Yet when necessity for an expanded military force demanded the use of all able personnel, the military used African American soldiers in both World War I and World War II. More than 900,000 African Americans served during World War II. The Tuskegee Airmen, trained to fly combat planes in that war, remain an example of African American men who pioneered in a field from which they had until then been blocked. Rutherford Hamlet Adkins, PhD, who became a leading science academic, also served with the Tuskegee Airmen.

After World War II, African American soldiers came home expecting to be treated like all other Americans, worthy of respect and equal access to

jobs, education and other aspects of society. But that was not always true. Yet beginning in 1945, the U.S. Army appointed a general to study its race polices, resulting in recommendations for improving the employment and treatment of African American soldiers. In 1946, the U.S. Army and Navy adopted policies of integration and equal rights for black service members. Though the new policies were not widely enforced, and the services continued to challenge integration, it was a step toward equality. That same year, President Truman established a civil rights committee to investigate racial violence, resulting in improvements in military integration over the next decade. By 1950, military job descriptions were opened to all without regard for race, and though there were many bumps in the road, by 1954, the secretary of defense announced that the last racially segregated unit in the armed forces had been abolished.

Many young African American Alexandrians were drafted, but many also enlisted in the military. It was a way to gain career training and experience and possibly to pay for further education after completing service. Vietnam was the last major military action for which our country still relied on the draft. Today, the United States relies on an all-volunteer military force.

Leo A. Brooks Sr.

August 9, 1932–

Leo A. Brooks Sr. is the only Parker-Gray High School graduate to reach the rank of general. He comes from a family of historic achievers that valued education. Leo and his two sons have accomplished a national milestone: they are the only African American family in the history of our nation to have a father and two sons become generals in any military service.

Looking back to the beginning of the Civil War, Richard Henry Brooks, Leo's great-grandfather, joined the Union army as a horse handler after breaking away from a plantation in Haymarket, Virginia. Thus, a Brooks family military tradition was started. Richard Brooks was an adult when the wife of the captain he served taught him to read and write. His grandson Houston, Leo's father, who had been instilled with the desire to educate his children, saw to it that all of his five children attended college. All have earned graduate degrees. Leo's siblings are Dr.

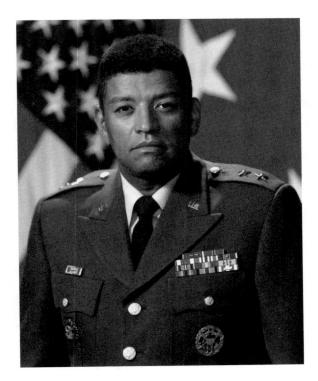

Brigadier General Leo A.
Brooks Sr. *Photo courtesy of Leo
A. Brooks Sr.*

Houston G. Brooks Jr., Henry C. Brooks, Nellie Brooks Quander and the
Honorable Francis K. Brooks.

Leo A. Brooks was born on August 9, 1932, in Alexandria to the Reverend
Houston G. Brooks and Evelyn Lemon Brooks. He attended Parker-Gray
Elementary and High School. As a student, Leo was president of his class
for two years and student body president his senior year. Upon graduation
from high school, he attended Virginia State University. There he became
president of his fraternity, president of the student government association
and student conductor of the college band. He earned a bachelor's degree
in instrumental music education in 1954. He also earned a commission as
a second lieutenant in the U.S. Army. He later earned a master's degree
in financial management from The George Washington University in the
District of Columbia.

Brooks married Naomi Lewis, a star Parker-Gray athlete who earned both
bachelor's and master's degrees in elementary education from Virginia State
University. Over the years, she taught in public schools, military education
programs and at Central State University in Ohio.

After thirty years of service and having reached the rank of major general, Brooks retired from the service early to become the managing director of the City of Philadelphia, thus retiring as a brigadier general. Both of his sons attended the United States Military Academy at West Point in New York. Leo A. Brooks Jr. is now a senior vice-president at Boeing Aircraft Corporation, having also retired as a brigadier general. The promotion of Vincent K. Brooks from lieutenant general to four-star general was confirmed by the U.S. Senate in March 2013, and he will become commanding general of the United States Army Pacific, stationed in Hawaii. The Brookses' daughter, Marquita, graduated from Howard University Law School and practices law in Washington, D.C.

WAYNE LAMONT JORDAN

September 3, 1946–March 17, 1967

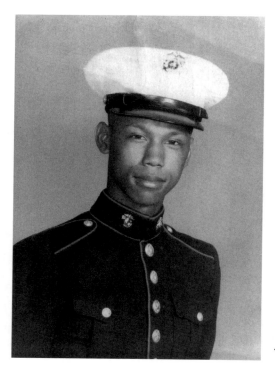

Lance Corporal Wayne Lamont Jordan, U.S. Marine Corps, died serving his country in South Vietnam. He was born in Alexandria, Virginia on September 3, 1946, the first-born son of Peggy and William Jordan. He attended Charles Houston Elementary School. After graduating from Parker-Gray High School in 1964, he tried

A fallen soldier—Lance Corporal Wayne Lamont Jordan of the U.S. Marine Corps. *Photo courtesy of Patricia Jordan Campbell, Alexandria, Virginia and Gray Jordan, Accokeek, Maryland.*

out for the Pittsburgh Pirates professional baseball team but was shortly cut from the squad. It was then that he proudly enlisted in the United States Marine Corps and began serving his country. In 1965, Wayne was called to duty in Vietnam, where he served for nearly two years as a machine gunner with L Company, 3rd Battalion, 4th Marines. On March 17, 1967, Corporal Jordan lost his life in an attempt to save a fellow marine's life during a violent attack in Da Nang, Quang Tri Province.

Wayne was an exemplary student, a member of Ebenezer Baptist Church, a Boy Scout and a fine gentleman and is still sorely missed and lovingly remembered by his family and all that knew him. His name is listed on the Vietnam Veterans Memorial wall at Panel 16E, Line 101. He was awarded the Purple Heart, National Defense, Vietnam Service and Vietnam Campaign medals.

JOSEPH OSBORNE KAHOE JR.

March 4, 1917–April 17, 1998

Joseph Osborne Kahoe Jr. rose to the rank of major in the United States Army after first serving as an enlisted man. Upon retirement, he settled in Alexandria, where he later received many awards for his civic involvement. He was most proud of being recognized during a fiftieth anniversary commemoration of World War II at which he represented black soldiers during a tribute recognizing the integral part they played in the war. During the commemoration activities, he was an honored guest of President Bill Clinton at an event held in the White House Rose Garden. On another occasion, Major Kahoe accompanied President Clinton to Arlington National Cemetery during a wreath-laying ceremony that commemorated World War II veterans. In 1996, he was the subject of a feature article in *The Washington Post* that explored his experiences as a soldier in that war. He was also featured in a documentary that is now in the National Archives. The film is shown to schoolchildren worldwide to educate them on the roles that African Americans played in World War II.

Kahoe was born on March 4, 1917, in New Orleans, Louisiana. He began his education in New Orleans but then moved with his family to Chicago, where he graduated from high school. At eighteen, Kahoe enlisted in the

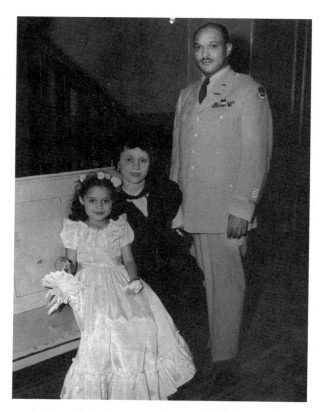

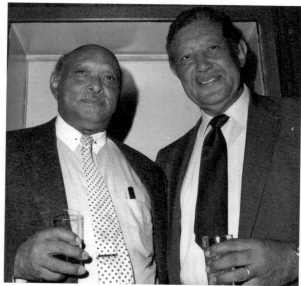

Top: Major Joseph Osborne Kahoe Jr., Purple Heart recipient and community leader, shown with his first wife, Laura, and daughter, Gayle. *Photo courtesy of Ferdinand T. Day and Gwen Day Fuller, Alexandria, Virginia.*

Bottom: Major Joseph Osborne Kahoe Jr. (left) and Ferdinand T. Day, community leader. *Photo courtesy of Ferdinand T. Day and Gwen Day Fuller, Alexandria, Virginia.*

U.S. Army. While stationed at Fort Belvoir, Virginia, he met Laura Luckett, daughter of Mr. and Mrs. Earl Luckett of Alexandria. The two married and had a daughter, Gayle. After a six-year tour of duty in the cavalry, Kahoe received an honorable discharge from the enlisted ranks of the army.

In 1942, the U.S. Army offered Kahoe an opportunity to reunite with the military through Officer Candidate School, after which he was commissioned a second lieutenant and went on to serve his country during World War II. Assigned to the 761st Tank Battalion (the first black tank division to see battle in the war), Kahoe was awarded the Purple Heart for wounds received during the Battle of the Bulge. He received numerous other decorations recognizing his valiant service during the war.

While Kahoe was serving in Europe during World War II, his wife, Laura, lived on Alfred Street in Alexandria with their daughter, Gayle Elaine. In 1946, Laura and Gayle moved to Germany to join him while he served with the Occupation Forces. Kahoe's list of commendations grew over the next twenty years while he rose to the rank of major. He retired from the army in 1962. After settling in Alexandria, he became an advocate for community programs that fostered the betterment of people of color.

In 1973, Kahoe, by then a widower, married Cynthia Hill, and they had a son, Joseph O. Kahoe III. Kahoe became active in Alexandria civic and military organizations and also regularly attended the annual reunions of his beloved 761st Tank Battalion. He was a life member of the Alexandria branch of the NAACP and served as its president. He was also a member of the Hopkins House Association, where he was a loan officer, and held numerous positions in the Departmental Progressive Club. He belonged to American Legion Post No. 129. At the national level, he served with Catholic Charities and the President's Council on Aging.

On April 17, 1998, after a brief illness, Joseph O. Kahoe Jr. died at Alexandria Hospital. He was buried at Arlington National Cemetery.

HARRY F. RICHARDSON JR.

November 29, 1947–January 31, 1968

Harry Frazier Richardson was born in Alexandria, Virginia, on November 29, 1947. He attended Parker-Gray High School, graduating in 1966. He was

drafted into the United States Army and after training began a tour of duty in Vietnam on January 4, 1968, as a private first class in C Company of the 716th Military Police Battalion, 89th MP GROUP, 18th MP Brigade, USARV.

Private First Class Richardson was killed outright by small-arms fire in combat with the enemy on January 31, 1968, just weeks after arriving in country. He is remembered by his family and friends. His name is listed on the Vietnam Memorial Wall in Washington, D.C., on Panel 36E, Line 32. He was awarded the Purple Heart, National Defense, Vietnam Service and Vietnam Campaign medals.

THOMAS H. TURNER

October 11, 1930–

Thomas H. "Tom" Turner is a native Alexandrian who became a United States Air Force pilot and rose to the rank of lieutenant colonel. He spent nearly ten years as a B-47 pilot and aircraft commander during the Cold War period and stayed prepared to strike the "big enemy" during the Sputnik satellite scare of the 1950s, the Lebanon affair and the Cuban Missile Crisis of the 1960s. He later transferred to transport aircraft, where he became an aircraft commander on C-141s, the first generation of jet cargo aircraft. He flew many missions into Southeast Asia in support of the Vietnam War effort until a medical condition caused his suspension from flying duties in 1967.

The son of Howard Turner and Hattie Marshall of 503 South Columbus Street, Tom was one of twelve children. At Parker-Gray High School, from which he graduated in 1948, he played football and ran track. He attended Savannah State College on an athletic scholarship through the middle of his junior year, at which time he enlisted in the Air Force during the Korean War. During his career as an enlisted man (1951–53), Turner served in the cartography, photomapping and photo-intelligence fields until he was called to Air Force Officer Candidate School. He was commissioned as an officer in June 1953 and was just a few days from completing Air Force Aircraft Controller School when the Korean War ended. He declined to become a regular officer, an offer that would have required an overseas assignment to Germany as an aircraft controller. Thus, he was immediately released from active service into the inactive reserve force in September 1953.

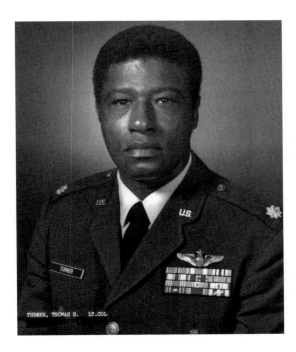

Lieutenant Colonel Thomas H. Turner, U.S. Air Force. *Photo courtesy of Thomas H. Turner, Tucson, Arizona.*

Turner took a job as a cartographic compiler with the United States Geological Survey, Special Maps Branch, in Washington, D.C., until he was recalled to active duty in the Air Force in May 1955. He decided to pursue a flying career and received his pilot wings in jet aircraft in June 1956. While on active duty as a B-47 combat-ready jet bomber pilot, he also completed his undergraduate degree requirements in biology and chemistry, graduating cum laude from Savannah State College in June 1959.

As an officer, Turner's professional schooling included completion of the Air War College, the Industrial College of the Armed Forces, Command and General Staff College and Squadron Officer School. He also took advanced courses toward a master's degree from the University of Nebraska and the University of Maryland.

Turner served in a variety of air transportation, management, command and staff positions in Guam, Vietnam, Japan, Korea and the continental United States during his twenty-eight years of military service. After retiring from the U.S. Air Force on July 1, 1979, he worked for United Services Life Insurance Company and USLICO Securities until he fully retired in 1992. Colonel Turner is married and has five children, eight grandchildren and eight great-grandchildren. He now resides in Tucson, Arizona.

RAYMOND LEROY "PORK CHOP" WILLIAMS

March 25, 1944–May 13, 1969

Raymond Leroy "Pork Chop" Williams's life was cut short when he became a casualty of the Vietnam War.

Williams was a popular student at Parker-Gray High School, where he belonged to the History Club, the "P" Club (a letter club) and the Art Club. He was also a captain of the football team. The nickname "Pork Chop" came from his love of that particular food. One of his best friends recalled that Pork Chop wanted to be a teacher. She remembered that when Parker-Gray's art teacher was preparing to take a long leave of absence, the teacher placed Raymond in charge of the class until a replacement instructor could be found. Raymond, a senior at the time, taught the class for several weeks until a teacher from Virginia State College took over. Raymond controlled the class, led them in building a major interdepartmental art project involving cherry tree decorations and earned the respect of his fellow students. He graduated in 1962.

Williams joined the United States Army, becoming a private first class, and was deployed on October 26, 1968, to Quang Tin Province in South Vietnam as a member of D Company, 3rd Battalion, 196th Infantry Brigade of the Americal Division. On May 13, 1969, he ran into enemy fighting. He died outright of multiple fragmentation wounds. He was just twenty-five years old and never realized his dream to become a teacher.

Private Raymond Leroy Williams.
Photo courtesy of George and Doris Washington, Woodbridge, Virginia.

Raymond Leroy Williams, a former Parker-Gray High School leader and football player. *Alexandria Public School Archives/Records, Alexandria, Virginia.*

Raymond's name appears on the wall of the Vietnam Memorial in Washington, D.C. on Panel W25, Line 114. There he is memorialized as a fallen soldier who won the Purple Heart, National Defense, Vietnam Service and Vietnam Campaign medals. However, many of his former classmates will always remember him for his potential to become a great teacher. His siblings still live in the Washington metropolitan area.

Chapter 7

RELIGION

V ery early in the history of the city of Alexandria, African Americans attended white churches with their masters or employers. Three white churches with large African American populations were the Alexandria Baptist Society, Trinity Church and Christ Church. These three churches subsequently established three African American churches in Alexandria: Alfred Street Baptist Church, Roberts Memorial United Methodist Church and Meade Memorial Episcopal Church.

The Alexandria Baptist Society had its first black members in 1803. By 1806, the society's black members started the Colored Baptist Society of Alexandria as a "conjoined" church with the Alexandria Baptist Society. In 1842, the black members of the Colored Baptist Society purchased their church site on Alfred Street. During the course of the history of the Colored Baptist Society, the group changed the name from the African Baptist Church to First African Baptist Church and in the 1870s changed the name once more to Alfred Street Baptist Church, the name it still bears today. Historically, Alfred Street Baptist Church was made up of free and enslaved African Americans. Today, Alfred Street Baptist Church is a mega church with a large African American congregation in Alexandria.

Trinity Church was a Methodist Episcopal church. By 1800, the African American congregation was growing to the point that in 1834, land was purchased for the African Americans to have their own church. This congregation included both free and enslaved African Americans prior to the Civil War. Roberts Memorial United Methodist Church went through

several name changes before adopting its current name. Today, Roberts Memorial United Methodist Church is the oldest African American Methodist church in the state of Virginia.

Christ Church recorded African Americans in its congregation during the 1800s. After the Civil War, Christ Church, St. Paul's and Grace Churches, Virginia Theological Seminary friends and others donated money to build a mission church. This was the beginning of Meade Memorial Episcopal Church. Meade's congregation was made up of free and formerly enslaved African Americans. Today, Meade Memorial continues to carry out its church mission along with many public service programs for the Alexandria community.

Other early churches in which some of the ministers and individuals written about in this book were active are Shiloh Baptist Church, founded in 1863; Third Baptist Church, also started in 1863; and Ebenezer Baptist Church, begun in 1881.

Alfred Street Baptist Church, Meade Memorial Episcopal Church and Ebenezer Baptist Church are the houses of worship in Alexandria where the four ministers described in this chapter officiated at services and helped and influenced their congregations. Those pastors are remembered for their dedication and the influence they had in the city of Alexandria.

Reverend Andrew Warren Adkins was one of Alfred Street Baptist Church's well-known ministers. He began his pastoral guidance in 1920 and maintained a long tradition of implementing educational programs at the church. Reverend Adkins also became a teacher at Parker-Gray School the same year he took up his pastorate and was instrumental in transforming Parker-Gray into a high school.

Reverend Canon John Candler Davis was a pastor at Meade Memorial Episcopal Church during the mid-twentieth century. Due to his physical appearance, Reverend Davis was able to attend events at establishments that were considered "white only." He encouraged his congregation to become active in the civil rights movement. He once served as the honorary canon at Trinity Cathedral in Monrovia, Liberia.

Reverend John O. Peterson was a well-known pastor at Alfred Street Baptist Church during the twentieth and twenty-first centuries. He increased the membership of the church and laid the foundations for two major construction projects. Reverend Peterson was a pioneer in elevating the role of women and youth in his church. He actively supported the integration of Alexandria public schools.

The Reverend Dr. N. Howard Stanton was pastor at Ebenezer Baptist Church in the late 1920s to late 1930s. He taught at Parker-Gray and later

taught at several colleges. He was a mentor to many and a member of many organizations in Alexandria. In 1965, he was the first African American in the twentieth century to be elected to the office of justice of the peace in Alexandria. But before he was sworn in, the office was eliminated.

These remarkable ministers influenced other churches and helped change the course of history of Alexandria's African American community. Their biographical narratives reveal their roles in reshaping the social structure of the city and how important they are to the history of their community.

REVEREND ANDREW W. ADKINS

February 26, 1884–November 14, 1963

The Reverend Andrew Warren Adkins began his forty-three-year pastorate at Alfred Street Baptist Church in Alexandria on the first Sunday in October 1920 when he was thirty-six years old. Prior to his service in Alexandria, he had been pastor at the Grafton Baptist Church in Middlesex, Virginia, a small community on the eastern shore, just off U.S. Highway 13 near Chincoteague.

Alfred Street Baptist Church had a long history of involvement in the education of Negroes in Alexandria going as far back as the 1820s, and Reverend Adkins continued that tradition when he came to Alfred Street. The church's educational efforts were often carried out through the public schools and other education-related efforts such as public libraries. For instance, in 1917, Alfred Street Baptist opened a 1,600-volume library in the basement of the church because the city of Alexandria was without library facilities for Negroes. A lending book showing the name, date and number of books borrowed by each individual still exists among church records. Newspaper reports of the times often reported that Dr. Adkins was a featured speaker, providing sermons, invocations and benedictions at public events and celebrations in the Alexandria community.

In the same year that he came to Alfred Street Baptist, Reverend Adkins also began teaching at Parker-Gray Elementary School. Eventually, he and others succeeded in persuading Alexandria city officials of the need for a Negro high school in Alexandria. From 1921 until his retirement in 1954,

Left to right: Principal William H. Pitts Sr., Leo A. Brooks and the Reverend Andrew Warren Adkins of Alfred Street Baptist Church (who also taught at Parker-Gray High School). Other men unknown. *Courtesy of Alexandria Public School Archives/Records, Alexandria, Virginia.*

Dr. Adkins taught mathematics at Parker-Gray School. Adkins also served as an oratorical coach at Parker-Gray, according to a 1951 article in the *Baltimore Afro-American.*

In 1967, four years after his death, Alexandria dedicated a ninety-unit housing project, naming it the Andrew Adkins Homes in the reverend's honor. The Adkins apartments, located in ten long, brick buildings built to look like colonial town houses, still stand on a block and a half of land located between Madison, Fayette and Wythe Streets. At the time of their construction, Parker-Gray High School still stood across the street from the housing project.

The Reverend Adkins was born in Charles City County, Virginia, near the towns of Lynchburg and Farmville, on February 26, 1884. He graduated from Virginia Union University with Bachelor of Arts and Bachelor of Divinity degrees. He received an honorary degree from Virginia Union in 1961.While serving as pastor in Middlesex, he also taught at the Middlesex Training School. He married Miss Mattie Hamlette of Newport News,

Virginia, on June 15, 1918. A graduate of Thyne Institute in Chase City, Virginia, she had been a teacher in Newport News. The Adkins eventually had six children.

The Reverend Dr. Adkins died on November 14, 1963, of a heart attack. He was survived by his wife, Mattie; three daughters: Andretta Alexander of Washington, D.C., Barbara Ridley of Petersburg, Virginia, and Teresa Lenoir of St. Louis; and three sons: Aldrich of Petersburg, Rutherford of Nashville, Tennessee, and Robert of Alexandria.

REVEREND CANON JOHN C. DAVIS

September 12, 1907–July 5, 1990

The Reverend Canon John Candler Davis, pastor of Meade Memorial Episcopal Church from 1959 to 1972, once served as the honorary canon at Trinity Cathedral in Monrovia, Liberia. He was as discontent as his peers with the status quo in Alexandria. His physical appearance allowed him to infiltrate white organizations of the city, such as the local rotary club, where open discussions were conducted about controlling the resistance in the black community. As an activist who encouraged and pressed his congregation to get involved in the civil rights movement, Father Davis took advantage of his appearance, using his access and influence to work with other community activists, such as the Secret Seven, to change the status quo.

Father Davis formed a working relationship with Sterling Tucker, an assistant secretary at the Department of Housing and Urban Development (HUD) for Fair Housing, who became president of the Washington Urban League. Both men were from Cleveland, Ohio, and were determined to right the wrongs in their communities. The Urban League had the mission and organizational structure within which Alexandria's segregation-related issues could be more effectively addressed. In the early 1970s, coordination between Father Davis and Sterling Tucker resulted in the establishment within the city of Alexandria of a Northern Virginia branch of the Washington Urban League. Father John C. Davis was a catalyst for change in this community.

John Candler Davis was born September 12, 1907, in Webster, North Carolina, to the Reverend John H. Davis and his wife, Carrie Love Davis. He attended Riverview Grade School and graduated from high school in

Canon John Candler Davis of Meade Memorial Episcopal Church. *Courtesy of Virginia Theological Seminary Archives, Alexandria, Virginia.*

Reidsville, North Carolina. He attended Fisk University and New York University and received his BA degree from Saint Augustine's College in Raleigh, North Carolina. He also received a Bachelor of Divinity degree from Bishop Payne Divinity School and earned his doctorate from Western Reserve University (now Case Western Reserve University).

Canon Davis was married to Ethel Norris of Petersburg, Virginia, until her death. The couple had no children. His second wife was Antoinette Hamilton of Long Island, New York. She also predeceased him. He had one stepson, Lester Hamilton. Father Davis died in Alexandria on July 5, 1990.

REVEREND DR. JOHN O. PETERSON

July 21, 1934–March 22, 2011

The Reverend John Otis Peterson was the pastor of Alfred Street Baptist Church from 1964 until 2006. At Alfred Street Baptist, Peterson oversaw the internal restructuring of church organizations, needed as a response to growth, and the raising of capital to fund that growth. The church united under Pastor Peterson's leadership to overcome many challenges and champion many causes. He helped the church deal with urban renewal conflicts, parking requirements and architectural review board requirements. Under his leadership, the church's membership grew from fewer than 300 to more than 2,800. The growing congregation created the need for major construction projects in 1981 and 1994. The operating budget grew from $1,200 in 1964 to $1.6 million in 1997.

Peterson championed elevating the role of women and youth. He actively supported the integration of Alexandria's schools and international missionary work and fostered community involvement. In 1979, Pastor Peterson ordained Mary Wair as the first female African American Baptist deacon in Northern Virginia. In 1980, he ordained Sister Doris Ashton as the first African American Baptist woman to the Christian ministry in the state of Virginia. He ordained a total of six female ministers and fifteen female deacons.

Pastor Peterson came to Alexandria at the age of thirty-one to fill the position at Alfred Street left vacant by the death of the previous pastor, the Reverend Andrew Adkins. Peterson was president of the Baptist Ministers Conference in Alexandria, third vice-president of the Northern Virginia Baptist Association, chaplain of the Alexandria Police Department and Alexandria Hospital, president of the Virginia Baptist General Convention, president of the Lott Carey Baptist Foreign Mission Convention and vice-president of the Baptist World Alliance. He also served on the board of trustees at his alma mater, Virginia Union University.

Peterson was born July 21, 1934, in Horse Head, Northumberland County, in Virginia's Northern Neck, the son of Hiram Ernest Peterson Sr. and Marie Haynie Nutt Peterson. He showed early signs of strong religious leadership ability as he taught Sunday school at age twelve and served as Sunday school superintendent at age sixteen in his father's church. After graduating from Julian Rosenwall High School in 1951 as class valedictorian, he entered

The Reverend John Otis Peterson of Alfred Street Baptist Church in his church office. *Photo courtesy of Rosette Graham and the Peterson family, Alfred Street Baptist Church, Alexandria, Virginia.*

Virginia Union University in Richmond to pursue a degree in mathematics and science. During his third year there, Peterson's father died, and he left school to help his mother and sister on the farm. While away from the university, he felt the call to the ministry and was ordained at First Baptist Church of Heathsville, his home church, on September 11, 1953, at age nineteen.

One year later, Peterson returned to Virginia Union, where he met his future wife, Joyce Keemer. He graduated in 1956 and married in 1957. He was elected as pastor of First Baptist Church of Louisa, where he served for nine years until he received the offer to preach at Alfred Street Baptist Church. During the first twenty-two years of his pastoral service, he also taught school, first in Warwick, Virginia, and then in Arlington County. He also earned a Master of Divinity degree from Virginia Union's School of Theology and received an honorary doctorate from Lynchburg Theological Seminary.

Dr. Peterson retired in 2006 due to ill health. He died on March 22, 2011, and was survived by his wife, Joyce Keemer Peterson; his daughter, Jewelette P. McDaniel; his son, John O. Peterson Jr.; and four grandchildren.

REVEREND DR. N. HOWARD STANTON

June 22, 1899–December 17, 1989

Napoleon Howard Stanton was a pastor, military officer, chaplain in the Civilian Conservation Corps and a teacher. He was also a civic activist in Alexandria and left a legacy of community service and leadership for his descendants to follow.

Stanton was born in Leesburg, Virginia, on June 22, 1899, to French and Magdalene Stanton. He attended Howard University and then transferred to Lincoln Jefferson University in Philadelphia, where he received a Bachelor of Arts degree. He also earned a Bachelor of Theology degree from Miller Theological College and a Doctor of Philosophy degree from Western University.

Stanton was commissioned in the U.S. Army in 1926, rising to the rank of captain in 1931. He served as a chaplain working in the camps of the Civilian Conservation Corps.

He taught at Parker-Gray School in Alexandria, the Washington Bible College, Luther Rice College and the Howard University Saturday College. He was dean of religion at Luther Rice College and the Saturday College of Howard University.

The Reverend Dr. Stanton was the first African American to run for Alexandria City Council in the 1900s. In 1965, he became the first and only black elected to the office of justice of the peace in Alexandria. But before he was sworn in, the office was eliminated, thereby preventing him from serving.

Reverend Stanton was a member of Alexandria's Elks Lodge No. 48, the Hopkins House Association and the Alexandria Voters Club and a past president of the Alexandria branch of the NAACP. He was a founding member of the Olympic Boy's Club, which during the process of desegregation merged with the Alexandria Boys Club to become the Alexandria Olympic Boys and Girls Club. Dr. Stanton worked toward equality and empowerment, blazing a trail for people before it was politically and socially popular. He received

The Reverend Dr. N.
Howard Stanton, pastor,
educator and politician.
*Alexandria Library, Special
Collections, Alexandria,
Virginia.*

a commendation from the City of Alexandria for his role in helping to calm
the city during times of racial unrest.

Except for his time in the military, Reverend Stanton lived in Alexandria
from 1926 until the time of his death. He was the pastor at numerous Baptist
churches during his seventy-plus years in the ministry. He was chosen as
interim pastor of Ebenezer Baptist Church in Alexandria in 1928 and
elected as pastor in 1930. He resigned from Ebenezer in 1937 but later
served as a pastor of First Baptist Church in Port Deposit, Maryland, and
at Mount Tabor Baptist in Linden, Virginia, commuting to these churches
from Alexandria. He was pastor of Nazareth Baptist Church in Orange,
Virginia, for fifty years, serving simultaneously at Mount Pisgah Baptist in
Gordonsville, Virginia, and the last twenty-two years prior to his death at
Ebenezer Baptist in Lignum, Virginia.

Dr. Stanton was married to native Alexandrian Esther N. Gray, who was a
teacher. The couple had seven children—the late Valeria S. Henderson, Lillian
S. Patterson, N. Howard Stanton Jr., Charles H. Stanton Sr., LeEtta S. Nowlin,
J.W. Stanton and Milton G. Stanton Sr.—and many grandchildren. Dr. Stanton
died in Alexandria on December 17, 1989. His wife predeceased him.

Chapter 8

SCIENCE

What was it about Parker-Gray High School that fostered an interest in science that is still prevalent today? We can't be sure, but perhaps one of the men profiled in this chapter had something to do with it. Mr. Ferris Holland was not only the first coach at Parker-Gray; he was also a science teacher at the school for thirty-two years before he retired in 1965. He is still remembered as a dedicated and inspiring teacher. He also had earned a master's degree, setting an example of the value of advanced education. So perhaps it is not surprising that three of the boys in the Brooks family who studied at Parker-Gray majored in a scientific field in college or graduate school and went on to varied careers using their degrees.

Houston, the oldest of the Brooks family children, went on from Parker-Gray to earn a bachelor's degree, two master's degrees and a doctorate in organic chemistry. He built a career in applied science research and held many patents. His brother Henry earned a bachelor's degree in divinity but then went on to earn a master's degree in theology and a doctorate in psychology, applying that science as a professor and director of clinical psychology at a seminary educating young ministers. The youngest Brooks brother, Francis, who graduated from Parker-Gray in 1961, went on to earn a bachelor's degree in chemistry and then a master's degree before becoming a high school science teacher and, later, a state legislator.

Rutherford Hamlet Adkins, a pastor's son, grew up in Alexandria. He studied physics in college before being interrupted by World War II. He was drafted while studying at Temple University and became a Tuskegee

Airman. After the war, he finished his undergraduate degree at Virginia State College before going on to earn a master's degree in physics from Howard University. He was the first African American to earn a doctorate from The Catholic University of America in Washington, D.C. He became a physics professor and later a college administrator as well as a visiting scientist and professor of physics at the United States Naval Academy.

These men had distinguished and valuable careers, advancing not only themselves but also, through example, mentoring and teaching, the careers of young people in their communities. In the years since their time at Parker-Gray, educational possibilities have widened, as have career opportunities. Thanks to the dedication of teachers like Mr. Holland and the pioneering efforts of the men described in this chapter, it is now much easier for African Americans to pursue academic and scientific careers—to aspire to be astronauts, for example. Many have become high-level scientists and professors, not only at historically black colleges and universities but all across academia and in the nation's advanced research laboratories.

RUTHERFORD H. ADKINS, PhD

November 21, 1924–February 6, 1998

Rutherford Hamlet Adkins (Lubby) was a Tuskegee Airman, the first African American to earn a doctorate (in physics) from The Catholic University of America and a professor and academic who became the president of Fisk University in Nashville, Tennessee.

Dr. Adkins attended public schools in Alexandria, where he was born to the Reverend Andrew W. Adkins, a longtime pastor of Alfred Street Baptist Church, and his wife, Mattie. Though as a youngster he thought he wanted to become a mechanic, his parents insisted he go to college. He attended Virginia Union University in Richmond but later transferred to Temple University in Philadelphia. While at Temple, he was drafted into the army during World War II. He received flight training at the Tuskegee Institute and was assigned to a fighter squadron with the 332nd Fighter Group. He flew fourteen combat missions with the Tuskegee Airmen.

After the war, Adkins returned to his studies in physics, choosing to attend Virginia State College (now University) in Petersburg, where he earned a BS

in 1947. He earned a master's degree in physics from Howard University in 1949 and a PhD in physics in 1955 from The Catholic University of America. He was the first African American to earn a doctorate from Catholic University.

During his career, Rutherford Adkins was a physics professor at Virginia State University, Tennessee State University, Fisk University, the United States Naval Academy, Morehouse College and the Georgia State Institute of Technology. He became president of Knoxville College in Tennessee from 1976 through 1981, when he retired for the first time. He then became a distinguished visiting scientist and professor of physics at the United States Naval Academy in Annapolis, Maryland, until 1990, when he became a member of the physics faculty at Atlanta's Morehouse College. In 1993, he returned to Fisk University in Nashville, Tennessee, serving first as associate dean, then as interim president and, in 1997, president.

Dr. Adkins was a member of Alpha Phi Alpha and Sigma Pi Phi fraternities, the American Association of Physicists, the National Society of Black Physicists and the American Baptist Men. He married his first wife secretly while they were students at Virginia State about 1946; she died in a car crash in 1967. On November 29, 1969, Dr. Adkins married Jacqueline S. Parker of Delaware. Miss Parker was the daughter of Mrs. Joseph Smith of Delaware. Their marriage took place in Richmond, Virginia. He married Nanci Cherry Pugh, an attorney, in November 1992.

Dr. Adkins died on February 6, 1998, and was buried in Nashville. He was survived by his wife, Nanci, three children from his first marriage— Sheila Adkins Scales, Mark and Theresa Ann—plus several stepchildren and grandchildren.

FRANCIS K. BROOKS

May 24, 1943–

Francis K. Brooks's first career was in the field of science education. He taught chemistry and chaired the science department of Montpelier High School in Vermont. His second career, in the field of politics, at first ran parallel to teaching. In 1983, he first ran for the Vermont State Legislature, where he served multiple two-year terms even as he continued his teaching

career. He retired from teaching in 1999. After his most recent legislative victory in 2006, he resigned from the Vermont House of Representatives in 2007 to run for the position of sergeant-at-arms of the Vermont State Legislature in Montpelier. He was elected to the position by the legislature and continues to serve there as of January 2012. During his service as a legislator, he focused on issues of housing and military affairs and was a member of the Appropriations Committee. He also served as a trustee of Norwich University from 1990 to 2005.

The youngest child of the Reverend Houston G. Brooks Sr. and his wife, Evelyn L. Brooks, Francis K. Brooks was born in Washington, D.C., on May 24, 1943. The family resided in Sunnyside, a community in the northern area of Alexandria.

After graduating from Parker-Gray High School in 1961, Francis earned a bachelor's degree in chemistry from Norwich University in Vermont in 1967. He went on to earn a master's degree from Clarkson College in Potsdam, New York. Mr. Brooks is married to the former Eunice W. Williams, and they have a son, Eric, and a daughter, Maria. His brothers Houston G. Brooks Jr. and Henry C. Brooks are deceased. His two surviving siblings are Major General Leo A. Brooks Sr. (retired) and a sister, Nellie Brooks Quander of Alexandria.

Henry C. Brooks

May 7, 1929–August 17, 2001

Henry C. Brooks used his education in psychology as both a professor and a pastor. The second son in the Brooks family was born in Alexandria on May 7, 1929. After graduating from Parker-Gray High School, he went on to Storer College, a historically black college in Harper's Ferry, West Virginia. He earned a Bachelor of Divinity degree from Storer, a Master of Sacred Theology degree from Andover Newton Theological Seminary and a doctorate in psychology from Boston University.

The Reverend Dr. Henry C. Brooks served as pastor of St. John's Baptist Church in Woburn, Massachusetts, from 1955 to 1959, when he became a professor and director of psychology and clinical studies at the Andover Newton Theological School in Newton, Massachusetts, serving there until

his retirement in 1995. As director of the school's clinical pastoral education program, he trained more than one thousand ministers and religious educators in spiritually based counseling and family crisis intervention.

Reverend Brooks was chaplain at Boston City Hospital (Boston Medical Center) from 1963 to 1993. He was a member of the General Board of American Baptist Churches and its Ministers and Missionaries Benefit Board. Among his many honors and awards were a Doctor of Divinity degree from Virginia Union University in Richmond, Virginia, the Cutting Medal for distinguished service in religion and medicine and being named Chaplain of the Year by the American Baptist Churches USA. He died at the age of seventy-two in Media, Pennsylvania, on August 17, 2001.

HOUSTON G. BROOKS JR.

December 11, 1927–May 11, 2011

Houston G. Brooks Jr., the eldest of the five children of the Reverend Houston G. Brooks, Sr. and his wife, Evelyn L. Brooks, was born December 11, 1927, in Chester, Pennsylvania. He had a distinguished career as a scientist. In the course of his career, he was employed by American Cyanamid and Ortho Diagnostics as a research scientist. He held many patents. Four were awarded in the 1990s, among them one for cell fixative composition and a method of staining cells without destroying the cell surface.

After his early education in Alexandria, Houston Brooks earned a bachelor's degree from Storer College in West Virginia. He completed two master's degrees, one from Tuskegee University in Alabama and the other from Iowa State University. He also earned a PhD in organic chemistry and veterinary physiology from Iowa State University. He served two years in the United States military and was stationed in Germany.

Mr. Brooks died in Somerset, New Jersey, on May 11, 2011. He was survived by his wife, Willa Brooks; two sons, Carl and Roger Brooks; a daughter, Alyson Brooks; two grandchildren; as well as his brothers, Leo and Francis, and his sister, Nellie Brooks Quander. His brother Henry predeceased him.

FERRIS L. HOLLAND

June 14, 1899–April 8, 1990

Ferris Holland taught general science, biology and chemistry at Parker-Gray High School and was also the school's first coach. A quiet, unassuming man, Mr. Holland inspired youngsters to sit up and take note, and he is well remembered for his teaching style.

In his early years at Parker-Gray, no funding was provided for athletics for Parker-Gray youth. On his own, Holland organized baseball and football sessions, becoming Parker-Gray's first athletic coach. He worked with his students until funding was finally provided and other teachers were enlisted to assist with coaching.

Mr. Holland worked at Parker-Gray as a teacher, coach and advisor for thirty-two years until the school closed in 1965. After his formal retirement, he worked as a substitute teacher in the Alexandria City Public Schools until 1981.

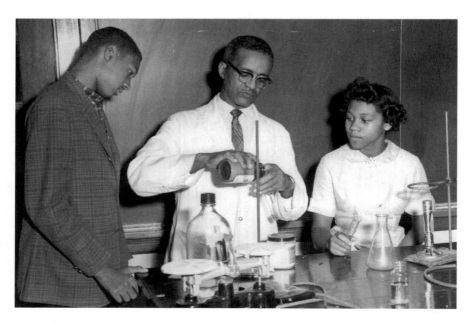

Ferris Holland (center), science teacher, coach and mentor, performing a science experiment for his students. *Alexandria Public School Archives/Records, Alexandria, Virginia.*

Ferris Holland was born on January 14, 1899, in Gum Springs, Virginia, a historically black Fairfax County subdivision off the Route 1 corridor. The Holland family was very active in the community and owned small businesses in the area. Gum Springs was largely segregated from the wider community but self-sufficient because of the collective cooperation of its members. The Gum Springs community had its own churches and businesses but no high school, so many families sent their children to the Parker-Gray High School in Alexandria.

Holland earned his bachelor's degree in science from the City College of New York and a master's degree in science from Morgan State University in Baltimore. In the Gum Springs community, a street is named for the Holland family for their contributions to the community. Mr. Holland died on April 8, 1990. He is remembered by many as a dedicated teacher, mentor and hero.

Chapter 9

SPORTS

Beginning in 1936, Parker-Gray High School began developing athletic teams. Dedicated coaches like Ferris Holland, Louis Johnson and Arnold Thurmond, who were also teachers, helped the athletes to sharpen their skills, become competitive, win games and develop pride within the school and Alexandria's African American neighborhoods.

Sports plays a valuable role in the lives of young people, teaching the importance of team effort and cooperation right alongside the critical importance of personal responsibility, self discipline and a good work ethic. Star athletes begin with natural talent, but they achieve top status through hard work and determination.

But the role of sports goes even further—it can be a stepping-stone to a college education, scholarships and, for some, to a professional career. Throughout its twenty-nine-year history as a high school (1936–65) Alexandria's Parker-Gray High School had dedicated coaches that helped the school excel in regional athletic competition but also worked to inspire students to excel academically so they could make their way in the wider world. Though it was a relatively small school, Parker-Gray had a large impact, often playing successfully against much larger high schools in Virginia, Maryland and the District of Columbia.

Even in the days of segregation, outstanding athletes were a source of pride in the African American communities, and Alexandria was no exception. To this day, sports participation remains a way to achieve recognition and to take pride in achieving excellence.

Several of the athletes we recognize in this chapter could just as easily have been recognized as educators. These men, who were successful athletes in their youth, chose as adults to become teachers and coaches. They exemplify the importance of role models and mentors to the youth growing up around them and were often critical influences in encouraging young people to attend college.

Arnold J. Thurmond is an example of a man whose most important role in life was as an educator who motivated young people to strive for academic success and to attend college. He was a fine athlete in both high school and college. After a remarkable period of military service during World War II in France, he earned an advanced degree and then chose to make a difference as a teacher, coach and administrator in the Alexandria school system.

Charles Price is another example of an outstanding athlete who turned to teaching and coaching after a successful college athletic career. The first Parker-Gray graduate to sign a professional football contract, he also became the first African American head coach in a high school in the Commonwealth of Virginia.

Horace Burton excelled as an athlete at Parker-Gray High School and at college. He briefly played professional football before becoming a successful businessman and union activist.

Oliver Ellis was an outstanding all-around athlete at both Parker-Gray and West Virginia State College, while Louis R. Harris was a renowned high school and college athlete who later earned an advanced degree and built a successful career as an industrial engineer.

William "Red" Jackson was a star, first at Parker-Gray and then in college. Named an All-American football player, he later became a respected college football coach. Bernard "Big" Scott was legendary in the Negro ball clubs of the mid-Atlantic region for his athletic prowess and feats of strength.

In 1950, Earl Lloyd became one of the first African Americans to be signed by the National Basketball Association (NBA), breaking the color barrier and paving the way for generations of future hoops players. When he played his first game with the Washington Capitols, he was the first African American to play in a game with an official NBA integrated team.

When segregation ended, African American coach Herman Boone led students of both races to forge a successful football team for the new T.C. Williams High School. His efforts were a struggle, but his success and that of players both black and white made the integration of the entire school go a bit more easily. When the school was able to field a successful team,

pride in its victories and the players who achieved them helped override the resistance of many Alexandrians who were still fighting against school integration long after it became the law of the land. That story is detailed in the 2000 film *Remember the Titans*.

These men inspired pride within the African American community in Alexandria and made a difference in advancing equality in sports even at the national level.

HORACE P. BURTON SR.

August 11, 1928–

Horace Burton's athletic career is a success story that begins with football, basketball, baseball and track and field at Parker-Gray High School in Alexandria. It continues through his college days playing football and baseball at Shaw University in Raleigh, North Carolina, and into the professional football arena with the Toronto Argonauts of the Canadian Football League.

Burton, along with Earl Lloyd, Oliver Ellis, Rozier Ware, Sherman McGuire and others, formed Parker-Gray's first basketball "Dream Team," gaining a reputation during the days of segregation in the South Atlantic High School Athletic Conference. Despite Parker-Gray's relatively small student population, small gymnasium and sparse transportation resources, they defeated much larger schools from the District of Columbia, Maryland and Virginia. Its football and baseball teams also compiled winning records and championship teams.

Shaw University, a liberal arts college, was founded by the Baptist Church in 1865 to provide theological education to freedmen after the Civil War and is the oldest historically black college in the United States. In 1947, his first year at Shaw, Burton was a starting tackle on the Central Intercollegiate Athletic Association (CIAA) championship team. Shaw completed an undefeated season with a win over South Carolina State University in the Capital Classic in Griffith Stadium in Washington, D.C. The following year, he was a starting catcher on Shaw's CIAA championship baseball team, on which former Parker-Gray star James L. Jackson also played as shortstop.

Horace Burton Sr. (left) played football at Parker-Gray High School, in college and as a professional with the Toronto Argonauts. Courtney Franklin Brooks was a musician and community leader. *Courtesy photo Lawrence P. Robinson, Gainesville, Virginia.*

After graduating from Shaw in 1951, Burton moved up to professional football with the Toronto Argonauts. In 1952, he was honored with other star athletes by the Washington Pigskin Club. Burton was inducted into Shaw University's Athletic Hall of Fame in 1996.

When Burton left professional football, he started his own construction business, Horace P. Burton & Sons. He became active with the 456 Labor Union, AFL-CIO. He retired in 1993 but remains active with the Retiree Council, Union 637.

Burton was born in Mooresville, North Carolina, to Alfred Bernard Burton and Carey Caldwell. The family moved to Alexandria when Horace was three. He is married to the former Mary Louise Jones of Kinston, North Carolina, also is a Shawite. They are the proud parents of Sidonie Burton Davis, Horace P. Burton Jr., Estrellita Burton Allen, the Reverend Howard K. Burton, Vanessa Burton Wilder, Carey O. Burton and the Reverend Jerome H. Burton.

OLIVER "BUBBA" ELWOOD ELLIS

March 26, 1926–July 9, 1991

Oliver "Bubba" Ellis was one of the greatest of Parker-Gray High School's all around athletes. Born in Alexandria, he graduated from Parker-Gray High School in 1946 and from West Virginia State College in 1951.

At Parker-Gray, he excelled in basketball, baseball, football and track, outplaying opponents across the region. Though Alexandria was then a relatively small city, Bubba was well known in cities like Richmond and Petersburg with powerful teams like Armstrong and Peabody. Newspaper accounts of games of the time described Bubba as having performed "brilliantly." One such article declared, "The fading minutes of the

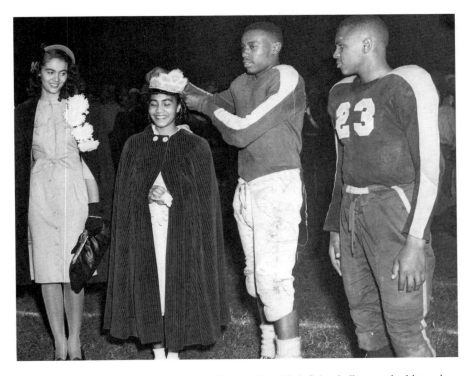

Oliver Elwood Ellis (second from right), a Parker-Gray High School all-around athlete who played football in college and on the Negro All-American football team, at a homecoming game. *Alexandria Public School Archives/Records, Alexandria, Virginia.*

final frame saw Ellis thrill with a fifty-yard pass interception which was nullified with a clipping penalty and a twenty-five-yard pass from Ellis to Lloyd. The teams marched off the field with the sidelines widely acclaiming Ellis as the greatest back exhibited in high school football here [Richmond]" in many years. Parker-Gray defeated Armstrong 20–12. Between September 1943 and June 1946, while Bubba played there, Parker-Gray won five basketball crowns, two football titles and four baseball championships.

Ellis started college at Howard University and later transferred to West Virginia State College, where he graduated in 1951 with a degree in physical education, health and safety. While at West Virginia, he was named All-Central Intercollegiate Athletic Association (CIAA) football halfback in 1948, 1949 and 1950 and to the Negro All-American football team in 1950. He was also assistant coach and captain of the baseball team from 1948 to 1950.

Ellis spent two years in the United States Army. He was a member of Elks Lodge No. 48 and of the Omega Phi Psi fraternity. Bubba was inducted into the Greater Washington Softball Hall of Fame in 1982 and into the West Virginia State College Sports Hall of Fame in 1984.

Mr. Ellis died at Howard University Hospital in Washington, D.C., in 1991. He was survived by his wife, Wilhelmina, and their children: Oliver II, Gregory and Keith.

Louis R. Harris Jr.

March 25, 1946–March 29, 1999

Louis R. Harris was a 1963 Parker-Gray High School graduate who achieved high honors in sports at the college and professional level and then built a career as an industrial engineer.

Harris was a straight-A student at Parker-Gray while being a dedicated member of the basketball, baseball and football teams. He was cited in a *Washington Post* article about Alexandria all-time sports greats as the outstanding football player of his high school senior year. Louis was one of the early African Americans to play in the Alexandria American Legion baseball league, and his play in that league continues to be a part of local

Louis R. Harris Jr. (far right), Parker-Gray High School athletic star, Kent State College football player, Pittsburgh Steelers football player and successful industrial engineer. *Photo courtesy of Shirley Anntranette Harris, Alexandria, Virginia.*

sports folklore. After graduation from Parker-Gray in 1963, Harris attended Kent State University in Ohio. At Kent State, he played football all four years, breaking records for interceptions in the 1965 and 1966 seasons. His jersey number was fourteen. He was selected to the First Team All Mid-American Conference at the free safety position his junior and senior years and received the honor of being selected as an All-American in both *Sports Illustrated* and *Playboy* magazine polls his senior year.

After graduating from Kent State in 1970 with a BS in industrial technology, Louis was recruited by the Pittsburgh Steelers and played as a defensive back for two years. His Steelers' jersey number was forty-nine. After leaving the team, Louis pursued and received an MS in applied technology from Southeastern University in Washington, D.C.

Louis began his professional career as an industrial engineer for Pfandler Company. He moved on to become a senior program manager for PEPCO, a project director for A.L. Nellum and Associates, a consultant for Applied

Management and Science and a regional support office liaison and utility program manager for the Federal Energy Management Program (FEMP). After his death, the U.S. Department of Energy created the Louis R. Harris Federal Energy and Water Management Award, which was given from 1999 to 2004 in his memory.

Louis received six outstanding and five superior Federal Energy Management Program performance awards and published numerous job-related articles and pamphlets. In his vocational exploits, excellence was his aim. Lou, as he was called, was inducted into the Parker-Gray Hall of Fame and the Kent State University Sports Hall of Fame.

Mr. Harris's community and civic outreach affiliations included serving as a board member of the Boy's Club of America. He was a member of Kappa Alpha Psi fraternity and the Alfred Street Baptist Church. He was a Little League basketball coach, a tennis coach for his son and a youth mentor with the Association of Energy Engineers. He belonged to the Washington Speaker's Bureau and had served in the United States Army Reserve.

Mr. Harris was married to the former Shirley Anntranette Hawkins, with whom he had a son, Louis Richard Harris III, affectionately known as Tré, who was a nationally ranked junior tennis player in his youth. Mr. Harris died in 1999. He is survived by his wife and son.

WILLIAM "RED" JACKSON

March 2, 1929–August 1, 2009

William Roland Jackson, known as "Red," was an All-American athlete. At Parker-Gray High School, he excelled in several major sports, including football, basketball and baseball.

After he graduated from Parker-Gray in 1948, many historically black colleges and universities (HBCUs) sought after Red, including Coach William "Bill" Bell at North Carolina Agricultural and Technical State University (A&T) in Greensboro. Bell was considered to be among the top three coaches in HBCUs, and North Carolina A&T successfully recruited Jackson in 1948. By 1950, he became first-string quarterback when the previous quarterback graduated. In 1951–52, Red was selected as both the All-Central Intercollegiate Athletic Association (CIAA) Conference quarterback

and an All-American quarterback. In Red's senior year in college, he led North Carolina A&T to the Black National Championship game.

Jackson was such a fine player that during his time with the Aggie Bulldogs, he was completely identified with the team and with Aggie Field. As a quarterback, Red set new university records in passing and scoring at the school. He was known for his technique of hiding the ball behind his back while faking handoffs to his running backs or wide receivers—a play known as the "bootleg."

As a student at North Carolina A&T, Red enrolled in the Reserve Officer Training Corps (ROTC). In 1952, he completed the ROTC requirements and was commissioned as a second lieutenant in the U.S. Army during the Korean War. While serving in the military, he played for the army alongside some future NFL quarterbacks and one Big Ten coach, John Cotta of the University of Wisconsin at Madison. After being honorably discharged in 1955, Jackson returned to A&T and completed his BA degree in sociology.

After A&T, Red played briefly with the Indianapolis Clowns baseball team of the Negro League. He went on to play quarterback with the Edmonton Eskimos in the Canadian Professional Football League for almost ten years (1955–64). After retirement from the Canadian Football League, Jackson coached at a number of colleges, including Benedict College, where he was inducted into the Athletic Hall of Fame. He retired from Benedict twice, the first time being in 1995. He was called back to work in 1998, and retired for good some years later.

William "Red" Jackson was born on March 2, 1929, in Alexandria. His parents, William Roland Jackson Sr. and Ruby Hill Jackson, lived at 527 Wilkes Street. Red was the youngest of five children.

Jackson died on August 1, 2009, at the age of eighty. He was survived by eight children.

EARL F. LLOYD

April 3, 1928–

Three years after Jackie Robinson broke the color barrier in baseball and four years before the *Brown v. Board of Education* decision integrated America's schools, Alexandria native Earl Lloyd made history in basketball.

Parker-Gray athletes. *Front row, from left*: Coach Louis Johnson, William "Red" Jackson, Rozier Ware, Earl Lloyd, Horace Burton, Oliver Ellis, Henry Brooks. *Back row, from left*: Lee McCoy (Malloy), Albert Burts, Robert "Tex" Matthews, Francis McGee, Louis Napper and Willie Rice. *Alexandria Black History Museum, Alexandria, Virginia.*

Earl Francis Lloyd, a graduate of Parker-Gray High School, was one of the first African Americans to break the National Basketball Association's (NBA) color barrier. Lloyd became part of the NBA on October 31, 1950, as a member of the Washington Capitols. Earl Lloyd only played seven games for the Capitols before he was drafted into the U.S. Army. During the Korean War, he served two years at Fort Sill in Oklahoma. After the army, Lloyd returned to basketball. In the 1950s, he played with the Syracuse Nationals and the Detroit Pistons, retiring in 1960.

Born April 3, 1928, in Alexandria, Lloyd was a star athlete during his years at Parker-Gray and is remembered fondly as a member of the class of 1946. He went on to graduate from West Virginia State University, where he led his team to an 80–14 record and won three Central Intercollegiate Athletic Association (CIAA) Conference Championships, including an undefeated season in 1947–48.

At six feet, six inches tall and 220 pounds, Earl Lloyd was known as "Big Cat." After retiring as a player, Lloyd became a coach. He became the first African American bench coach for the NBA when he was hired

by the Detroit Pistons. In 1970, he became the second African American head coach, a job he held until 1972. During his career, he coached Bob Lanier and Dave Bing, both Hall of Fame members. Lloyd is also credited with discovering Earl "The Pearl" Monroe during his time as an NBA scout. During his groundbreaking career, he often encountered prejudice, he said.

In 2010, Earl Lloyd published *Moonfixer: The Basketball Journey of Earl Lloyd*, the story of his life and career. In the acknowledgements, Lloyd thanks his Alexandria family and his Parker-Gray High School family. The book's title derives from a nickname given to him in college when a hazing ritual required him to reach up and "fix the moon." According to the NBA, it was also said that Lloyd earned this nickname due to his height and athletic prowess.

Looking back at his student days at Parker-Gray, Lloyd said in his book, "We had nothing—not a gym, not a baseball stadium, nothing. What we had, what saved us, was a magic coach named Louis Johnson."

The year 2003 marked the enshrinement of Earl Lloyd in the Naismith Basketball Hall of Fame. He was honored in Alexandria in 1994 at the Alexandria Black History Museum, in 2001 (Earl Lloyd Day at the Charles Houston Recreation Center) and in 2007, when the Earl Lloyd Court was dedicated at the T.C. Williams High School Gymnasium.

After his basketball career, Lloyd worked as an executive with the Dodge division of Chrysler in Detroit. He was also part of the Bing Group (a large Michigan steel company), owned by his friend (and former basketball player) David Bing. Now fully retired, Mr. Lloyd lives in a retirement community near Crossville, Tennessee. He still enjoys watching basketball on TV. Lloyd and his wife, Charlita, have three sons and four grandchildren. To many, Earl Lloyd is considered "the Jackie Robinson of basketball." He broke barriers and made the game better for others.

CHARLES L. PRICE

Born August 24, 1924–

Charles Llewellyn Price was a renowned athlete who excelled as a football player and coach, first at Parker-Gray High School and later on both the local and national levels.

Charles Llewellyn Price, football player and coach. *Photo courtesy of Char McCargo Bah, Stafford, Virginia.*

Price was born on August 24, 1924, in the Alexandria Hospital (then in the 200 block of South Washington Street, between Duke and Columbus Streets) to Isaiah "Ike" Price and Mable Porter Price. After graduating from Parker-Gray High School in 1942, he attended Virginia State College, where he initially played offensive and defensive tackle, earning the nickname "Bruiser." In 1945, he was a member of the Central Intercollegiate Athletic Association (CIAA) Championship football team and was named All-CIAA Conference fullback. Also that year, the Afro-American newspapers awarded him the "Afro MVP Award." In 1946–47, he was the assistant coach for the track, basketball and football teams at Parker-Gray.

In the spring of 1947, Price signed a professional football contract with the Los Angeles Dons and later with the Hawaiian Warriors (who won the Pacific Coast Championship), thus becoming the first Parker-Gray High School graduate to sign a professional football contract.

When he stopped playing professionally, Price returned to public education. For eleven years, he coached and taught at Lucy P. Addison High School in

Roanoke, Virginia, where he was head coach for the football, basketball and tennis teams. Moving back closer to home, from 1959 to 1964, he coached and taught at Luther Jackson High School in Fairfax County. In 1964, that football team had an undefeated season and won the state championship for the Virginia Interscholastic Association and Price was named Coach of the Year. Between 1965 and 1970, following desegregation, he became the first African American head coach in the Commonwealth of Virginia at Langley High School in Fairfax County. In 1970, Price became an assistant principal at Groveton High School, a position he held until his retirement in 1980.

Price was honored as a football player through induction into the Parker-Gray High School Hall of Fame, the Virginia State Hall of Fame and the CIAA Hall of Fame. He was further honored by being selected to the Fairfax County Hall of Fame as a football coach.

In 1948, Price married Marjorie Hopkins. They have two children, Harold and Claudia, both of whom became educators in Fairfax County (Harold retired as a junior high school principal, while Claudia was an elementary school assistant principal.)

Price has spent the past eight years on the board of directors of the Alexandria Sportsman's Club. He is a charter member of the Kappa Alpha Psi fraternity of Roanoke-Martinsville, Virginia, and a member of the Alexandria and Fairfax chapters as well. He has served each chapter as its polemarch (president).

BERNARD "BIG" SCOTT

c. 1908–May 2, 1956

According to Eddie Crane, longtime sports editor for the *Alexandria Gazette*, and many older Alexandrians such as Ferdinand Day, Big Scott was one of the most fabulous athletes in Alexandria's history. Although he was a native of Fredericksburg, he was widely known in Alexandria, as tales about him and his size and feats of strength, written by Jack Tulloch, appeared in the *Alexandria Gazette*. Other stories were told by those who saw him play football and baseball.

Big Scott weighed over three hundred pounds and stood a straight six-foot-five. He distinguished himself while playing with and against many of

the great Negro ball clubs and players at the old Municipal Stadium. Stories were told that Big Scott could throw a regulation-size football one hundred yards, even though he played on the line in actual games. He was also a strong-armed baseball catcher for a great many area teams.

Locally, Big Scott's best years were 1941–43, when he played for such baseball teams as the Lafayette Juniors, the Pearson All-Stars, the Departmental Athletic Club, the Roman Club and the Alexandria All Stars under the leadership and management of Ben Ashford and Willie McMurry.

Scott lived in Alexandria for more than thirty years, appearing in the Alexandria census in both 1930 and 1940. He was employed at Thomas J. Fannon and Sons for twenty years as a general handyman. He died in Alexandria on May 2, 1956. Funeral services were conducted at Mount Jezreel Baptist Church in Alexandria, and he was buried at Union Cemetery. Honorary pallbearers were some of his former teammates, including Charles R. Williams, Eunice Burts, Charles Monique, Son Turner, Ike Marshall, Perry Felton and Oscar Taylor.

Big Scott was survived by his wife, Ioniam; one son, Roland W. Scott; two daughters, Audrey Jane Scott and Barbara Jane Scott; his mother, Mrs. Lena G. Scott; and one sister, Ethel McCullough.

ARNOLD J. THURMOND

August 12, 1923–

Arnold J. Thurmond is respected as a longtime educator, coach and mentor in Alexandria, where he has lived much of his adult life. He also served with distinction in the U.S. Army during World War II.

Thurmond was born in Ethel, West Virginia, on August 12, 1923, and was educated in the public schools of Fayette County, West Virginia. He was the youngest of nine children, and his mother died when he was four or five years old. His father, a disabled former coal miner who had lost a leg in a mining accident, first asked a relative to care for Arnold and one of his older sisters. That effort failed, and the two youngest children became wards of the state and spent time in an orphanage before being placed with foster parents. Arnold speaks fondly of the foster parents who helped rear him during his formative years. Driven by curiosity, he always asked neighbors

Arnold J. Thurmond (far right), Parker-Gray High School teacher and coach of the Bull Dogs basketball team. *Photo courtesy of Lawrence P. Robinson, Gainesville, Virginia.*

how things worked and how they could be repaired, and he retained that love of fixing things throughout his life.

Thurmond was an excellent athlete, playing football, basketball and baseball and running track. Upon graduating from high school, he enrolled in Hampton Institute, but his education was interrupted when he was conscripted into the United States Army in 1943. After completing basic training at the infantry school at Fort Benning, Georgia, Thurmond's unit was sent to Europe in early 1944 and then participated in the invasion of France at Normandy, where both his skills as an auto repair mechanic and his high school knowledge of French proved very useful. Many years later, on November 25, 2009, Thurmond was among a group of African American veterans honored with the French Legion of Honor for their role in saving French people during World War II. The awards were presented at the French Embassy on Reservoir Road in Washington, D.C.

After being discharged from the army, Arnold returned to Hampton, where he earned a bachelor's degree in education and also played football. He later earned a master's degree from Wayne University in Detroit. He then set out to make his mark in teaching. He came to Alexandria in 1950 and took a

teaching position at Parker-Gray High School. Alexandria's public schools were segregated at the time, and Parker-Gray was located directly across the proverbial tracks from the larger, all-white George Washington (GW) High School, where the emphasis was on higher educational attainment following graduation. The emphasis for black children attending Parker-Gray was vocational studies. Early in his career, Thurmond taught industrial arts, both at Parker-Gray and as a roving teacher at other elementary schools. From the very beginning, however, he never lost his focus on the need for his students to attain higher education. He believed that if they were to be economically independent and competitive within the larger community, education was the key. He was convinced that this should be the goal for children everywhere.

Mr. Thurmond often spoke of his admiration for his mentor and principal, Mr. William Pitts, whom he described as masterful in his ability to extract funding for Parker-Gray's programs from the school board. In combination with a group of dedicated teachers, Mr. Pitts led his students to academic success.

In addition to his classroom responsibilities, Mr. Thurmond began coaching the school's basketball team, the Parker-Gray Bull Dogs. The entire community soon learned that the team was very much like its mascot—tenacious and doggedly determined to excel. The team earned a reputation for having skilled players, superior to any throughout the area. In 1957, the Bull Dog players clearly demonstrated their athletic prowess by winning the state championship. Three additional state championships ensued. Mr. Thurmond repeatedly led his team to victory, but he also worked with his players to maintain good academic standards, a feat that propelled his stars to pursue higher education when they graduated from Parker-Gray. Coach Thurmond's men were courted by colleges throughout the country, including Ohio State, the University of Washington, Connecticut University, Morgan State College and St. Augustine.

When Parker-Gray High School closed, Mr. Thurmond was transferred to GW High School as a counselor and dean of Monroe House, a school within the school, and later became assistant principal. As a testimony to his commitment to students, the GW 1970 graduating class honored Mr. Thurmond with a tribute. After retiring in 1985, Mr. Thurmond provided administrative oversight to the T.C. Williams night school effort directed at helping dropouts obtain high school diplomas.

In 1950, Arnold Thurmond married Alberta Newman, whom he met when he was a young teacher at Parker-Gray, where she was the secretary

and administrative assistant to Principal William Pitts. The couple had two sons, Jacy and Alan. Alberta Thurmond, who was Catholic, insisted that the boys attend Catholic schools. She died after a long illness in 2008. At the time of this writing, Mr. Thurmond lives in Arlington.

Son Jacy is an executive and attorney with the Social Security Administration. He is married and the father of a son, Michael, a law student at Wake Forest University, and a daughter, Alexis, a third-year pre-med student at the University of Virginia. Alan is a civil engineer with the National Aeronautics and Space Administration (NASA), and he and his wife have two daughters. Nicole is a medical student and Alana is majoring in architecture at Catholic University.

EPILOGUE

The careful reader will have noticed that some of the narratives in this volume were quite brief or lacked details for parts of the lives described. Many who lived in the earlier years of the period in question are deceased, and record keeping was often not reliable for the African American community of the era. We relied on genealogical searches to find the most accurate birth, marriage and death records available. Educational and sporting achievements were sometimes recorded in the African American press or local newspapers. For some individuals, we had only scraps of memory and oral history from older members of the community. We verified them as best we could from official records, obituaries, church funeral programs and other documentation. Internet files of digitized newspaper records have helped, as have other online sources.

This book weaves a story—too long untold—of Alexandria's black community. We wanted to give each individual his or her due, even as we are aware that the picture we paint here is incomplete. We've tried to put in as much as we could find in the way of available facts: birth and death dates, where they were educated, who they married, the names of parents and children. We want this book to be of value in itself, but we also see it as a starting point and a stepping-stone. We hope future writers and researchers will use the narratives and the list of contributors' names, along with our source list, to go further and continue to research and publish more information about Alexandria's African American history.

—CMB, GBH, APD, JEH and CW

SELECTED SOURCES

NEWSPAPERS, MAGAZINES, PROGRAMS AND REGISTERS

Alexandria Gazette

Alexandria Gazette Packet

Alexandria Port Packet

Alexandria, Virginia Funeral Programs (on file at the Alexandria Black History Museum)

Black History Celebration Souvenir Program for "Hoop Academy Project," February 2009

Hill's *Alexandria, Virginia City Directories* (located in the Alexandria Library Local History/Special Collection)

Journal of the National Medical Association

Lexington Herald-Leader

Living Legends of Alexandria 2007: A Photo-Documentary Record of Our Recent History

Living Legends of Alexandria 2008: A Photo-Documentary Record of Our Current History

Living Legends of Alexandria 2010: A Photo-Documentary Record of our Recent History

Southern Press (Durham, North Carolina)

St. Louis Post-Dispatch

St. Petersburg Times

The Associated Press Archive
The Baltimore Afro-American
The Baltimore Sun
The Cleveland Plain Dealer
The Miami Herald
The New Journal and Guide (Virginia's oldest weekly African American newspaper, published in Norfolk since 1900)
The Richmond Times Dispatch
The Washington Post and Times Herald Newspaper
The Washington Times
Tulsa World
Vital Statistic Birth Register, 1912–1929 (located in the Alexandria Library Local History/Special Collection)

WEBSITES

Alfred Street Baptist Church
www.alfredstreet.org

Ancestry.com
www.ancestry.com

Family Search
www.familysearch.org

Genealogy Bank
www.genealogybank.com

Heritage Quest
www.heritagequestonline.com

Hopkins House
www.hopkinshouse.org

Howard University
www.howard.edu

The Other Alexandria
www.theotheralexandria.com

Shaw University
www.shawu.edu

The Virtual Wall
www.virtualwall.org

INTERVIEWS

Telephone interviews with:

William Bracey
Constance H. Bradley
Phillip Bell
Francis K. Brooks
Marie E. Castillo
Arthur C. Dawkins, PhD
Dr. Nancy Durant Edmonds
Eudora Lyles Forrest
Rita Murphy Harris
Alice Bell Lewis Holland
Hopkins House Association President J. Glenn Hopkins
Becky May Jenkins
Lucian Johnson
Arthur Nelson
Lillian Stanton Patterson
Arlett Slaughter
Linwood M. Smith
Dorothy Evans Turner
Thomas H. Turner
Connie Chissell Young

E-mail interviews with:

Isabel Crocker
Johnathan L. Lyles Sr.
Mark Young

Personal interviews with:

Ferdinand T. Day
Nelson Greene
Nina Greene

Personal and telephone interviews with:

Leo A. Brooks Sr.
Corrine Dixon
Janice Howard

Telephone and e-mail interviews with:

Roland Burke
Shirley Anntranette Harris
Jacy Thurmond

INSTITUTIONS AND CHURCHES

Alexandria Black History Museum, Alexandria, Virginia
Alexandria Courthouse, Alexandria, Virginia
Alfred Street Baptist Church, Alexandria, Virginia
Ebenezer Baptist Church, Alexandria, Virginia
Kent State University Alumni Association, Kent, Ohio
Shiloh Baptist Church, Washington, D.C.
Third Baptist Church, Alexandria, Virginia

BOOKS AND ARTICLES

Brower, W.A. "Biographical Sketch of Arthur Dawkins, PhD." http://www.coas.howard.edu/music/huje/dawkins.htm.

Greenstein, Teddy. "Do You Know Me? Few Recall that Earl Lloyd Was the First Black Player in an NBA Game." *Sports Illustrated*, 1994.

Lloyd, Earl, and Sean Kirst. *Moonfixer: The Basketball Journey of Earl Lloyd*. New York: Syracuse University Press, 2010.

Pippenger, Wesley E. "Alexandria, Virginia–Marriages 1870–1892." Westminister, MD: Family Line Publications, 1994.

Saunders, Rick. "Greatest of All Time—Earl Lloyd Parker-Gray Basketball 1946." *Alexandria Gazette Packet*, August 17, 2006.

Telfair, Earl. *Black Athletes of the District of Columbia During the Segregated Years: Remembering*. Washington, D.C.: D.C. Collegians Athletic Association, 2000.

Wallace, Alton S. *I Once Was Young: History of Alfred Street Baptist Church, 1803–2003*. Littleton, MD: Tapestry Press, Ltd., 2003.

All materials used in researching this book will be available for future research use in the files of the Alexandria Black History Museum, 902 Wythe Street, Alexandria, VA, 22314, 703-746-4356.

ABOUT THE AUTHORS

Char McCargo Bah is a professional genealogist for the Alexandria Legacies—Freedmen's Cemetery Descendants Project of the City of Alexandria, an author and a public speaker. Audrey P. Davis is the acting director of the Alexandria Black History Museum. Gwendolyn Brown-Henderson is a native Alexandrian and retired United States government

Front row, from left: Char McCargo Bah and Gwen Brown-Henderson. *Back row, from left*: Christa Watters, James E. Henson Sr. and Audrey P. Davis. *Photo by Catherine Weinraub of Fairfax, Virginia.*

worker. James E. Henson Sr. is a retired attorney who grew up in Alexandria. Christa Watters is a freelance writer and editor who has lived in Alexandria for thirty years. This group came together to document the history of African Americans who were agents of change and served as Beacons of Light in Alexandria in the twentieth century.